The Pacific Northwest
LANDSCAPE

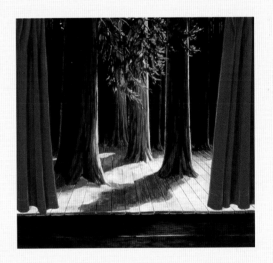

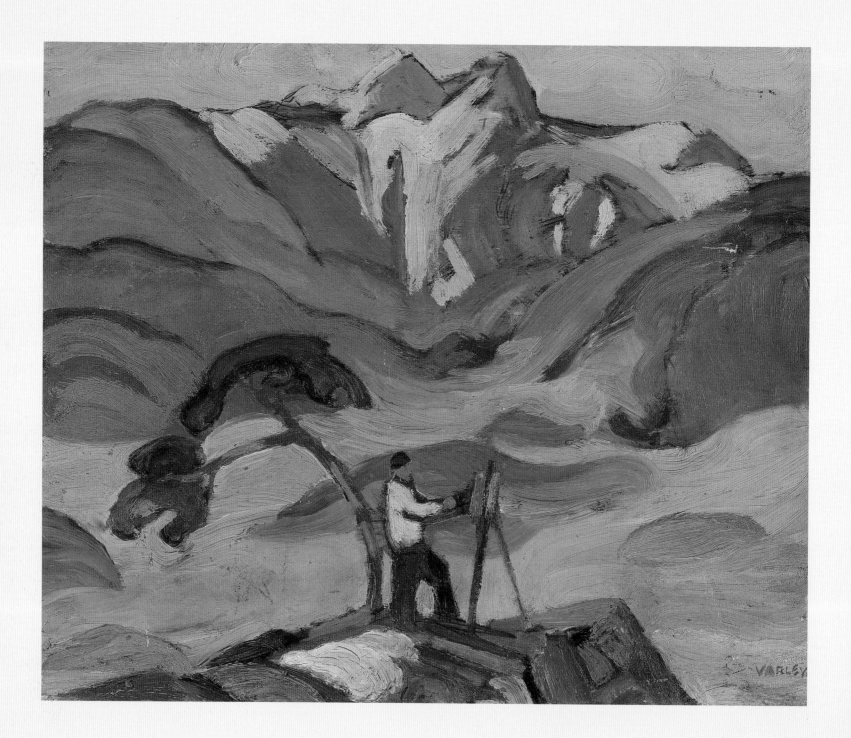

The Pacific Northwest
LANDSCAPE *A Painted History*

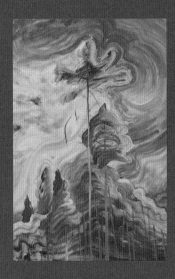

Edited by **Kitty Harmon**

Introduction by **Jonathan Raban**

SASQUATCH BOOKS
SEATTLE

ACKNOWLEDGMENTS

First of all, my gratitude to David Martin of Martin-Zambito Fine Art in Seattle, whose commitment to promoting Northwest regional artists and store of knowledge on this topic are prodigious; thanks for setting me on all the right paths. ⤳ A world of appreciation to Michael Parsons, for being exceedingly generous with his knowledge of Oregon painters, introductions to collectors, well-placed advice, and enthusiasm for this project. ⤳ Many thanks to Len and Jo Braarud of Braarud Fine Art in La Conner, Washington; Robert Heffel of Heffel Gallery in Vancouver; Allan Kollar of A. J. Kollar Fine Paintings in Seattle; John Olbrantz of the Hallie Ford Museum of Art in Salem, Oregon; Mayumi Tsutakawa of the Wing Luke Asian Museum in Seattle; and the many contemporary art galleries and private collectors who contributed images to this book. ⤳ Finally, thank you, Lisa Irwin, for always assisting, and Jonathan Raban, for seeing both the forest and the trees.

Published by Sasquatch Books
Printed in Hong Kong
Distributed in Canada by Raincoast Books, Ltd.
07 06 05 04 03 02 01 6 5 4 3 2 1

Cover and interior design: Karen Schober
Copy editor: Sherri Schultz

Library of Congress Cataloging in Publication Data
The Pacific Northwest landscape : a painted history / edited by Kitty Harmon ;
text by Jonathan Raban.
 p. cm.
 Includes bibliographical references.
 ISBN 1-57061-284-6
Landscape painting, American—Northwest, Pacific. 2. Northwest, Pacific—In art.
3. Landscape painters—Northwest, Pacific—Biography. I. Harmon,
Kitty. II. Raban, Jonathan.
ND1351.P33 2001
758'.1795'0973—dc21 2001020944

Sasquatch Books
615 Second Avenue
Seattle, Washington 98104
(206) 467-4300
www.SasquatchBooks.com
books@SasquatchBooks.com

COVER ART:
ALDEN MASON
Deception Pass | *1951*
watercolor, 17½ × 23⅝"
Collection of the Henry Art Gallery, Seattle.
Photo courtesty of the artist.

BACK COVER ART:
RON MCGAUGHEY
Beebe Bridge (Entering Chelan County) | *1996*
oil on canvas, 42 × 68"
Private collection. Courtesy of Martin-Zambito
Fine Art, Seattle

PAGE 1:
MICHAEL BROPHY
Tree Opera I | *1999*
oil on canvas, 78 × 84"
Collection of Mr. and Mrs. Mark Goodman,
Courtesy of Laura Russo Gallery, Portland
Photo: Bill Bachhuber

PAGE 2:
FRED H. VARLEY
Mountain Sketching | *c. 1929*
oil on panel, 12 x 15"
Art Gallery of Ontario, Toronto. Gift of Mrs. Doris
Huestis Mills Speirs, Pickering, Ontario, 1971.
Reproduced courtesy Estate of Kathleen G. McKay

PAGE 3:
EMILY CARR
Sunshine and Tumult | *c. 1938-39*
oil on paper laid on board, 34¼ × 22½"
Art Gallery of Hamilton, Ontario.
Bequest of H.S. Southam, Esq., 1966

FACING PAGE, TOP:
ROBERT O. ENGARD
Spokane Industrial | *1938*
watercolor, 19 × 14¾"
Collection of the artist. Courtesy of Martin-Zambito
Fine Art, Seattle

FACING PAGE, MIDDLE:
PAULINE JOHNSON
Untitled (Eastern Washington landscape) | *c. 1935*
watercolor, 18 × 24"
Courtesy of Martin-Zambito Fine Art, Seattle

FACING PAGE, LOWER:
JOE RENO
My Home Town | *1998*
oil on canvas, 24 × 40"
Collection of the artist, Courtesy of Bank
of America, Seattle
Photo: Eduardo Calderón

PAGE 144:
MICHAEL BROPHY
Curtain | *1999*
oil on canvas, 96 × 78"
Collection of the artist. Courtesy of Laura Russo Gallery,
Portland
Photo: Bill Bachhuber

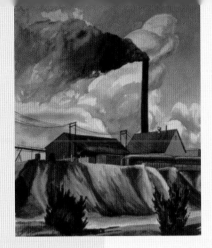

Contents

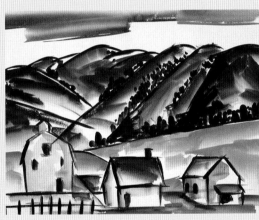

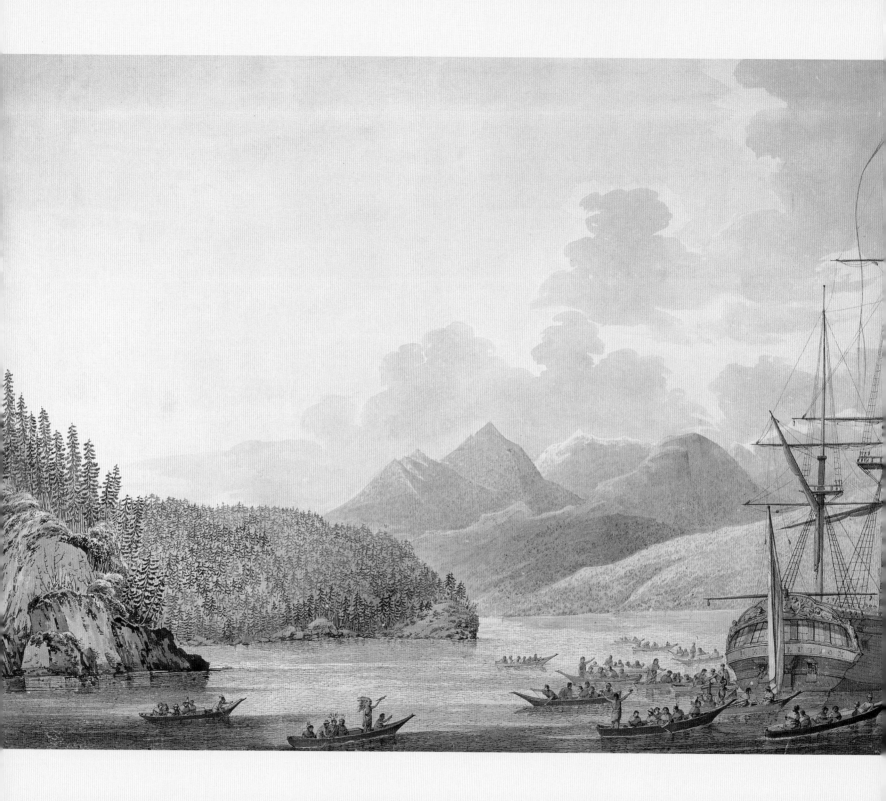

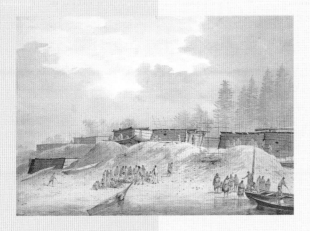

Introduction

By Jonathan Raban

THE FIRST WHITE ARTIST TO UNPACK HIS PAINTBOX IN THE PACIFIC NORTHWEST WAS JOHN WEBBER. In the spring of 1778, Captain Cook's *Resolution* put in to Nootka Sound on the west coast of Vancouver Island after a long northward haul up the Pacific Ocean from New Zealand, with stops in Tonga, Tahiti, and Hawaii. En route through Oceania, Webber, the official expedition artist, had painted a series of watercolors that are dominated by their exotic tropical greenery, and in which every palm frond has a life of its own.

Cook's ship left the palms, wiliwilis, breadfruit, and hibiscus of Hawaii on February 2; on March 29 it sailed into the great funnel-shaped approach to Nootka Sound, on the same latitude as the mouth of the English Channel. To British eyes, the Pacific Northwestern light falls at a familiar and homely angle. The vegetation is Scottish, the weather Irish. After Hawaii, Nootka Sound must have felt to the voyagers like a wet and windy corner of their own country. Cook named the Northwest coast New Albion, in honor of its teasing similarity to home.

Webber, who trained as a painter in Switzerland and Paris, clearly seems to have experienced a bout of déjà vu. In sharp contrast to his Tahitian and Hawaiian watercolors, the Nootka sketches render the local scenery (and "scenery" it is) in brisk pictorial shorthand, as Webber

composes the water, rock, pines, and mountains into a strikingly efficient and conventional landscape. We might be on the shore of Lac Léman or Lake Windermere here.

Like Cook, in his *A Voyage to the Pacific Ocean* (1784), Webber seems barely to notice the land itself, so preoccupied is he with the Indians in the foreground—their swan-necked cedar canoes, their curious timber dwellings, the frames on which they dry their salmon. In Paris, he had specialized in "picturesque peasant scenes," a useful preparation for his studies of Indian life. Though the figures are small on the page, they are exquisitely detailed and individuated. With a magnifying glass, you can pick out their conical hats, woven from cedar bark, and capes made from sea-otter hides. Given his education, Webber must almost certainly have encountered the ideas of Rousseau, and his Pacific Northwest is the habitat of "natural man," drawn with the fastidious zeal of a keen amateur anthropologist.

In 1791 and 1792, more than a decade after *Resolution*'s flying visit to the Northwest (from Nootka, Cook sailed offshore to the Gulf of Alaska, sighting land to starboard but not stopping there), Spanish and British expeditions were cruising through the region, proving the insularity of Vancouver Island and charting Puget Sound. The Spaniards shipped professional artists (Tomás de Suría, José Cardero, Atanásio Echeverría), while the English, under Captain George Vancouver, made do with the artistic efforts of a bunch of talented midshipmen, including John Sykes, Harry Humphrys, and Thomas Heddington. From the mass of sketches that came home to London and Madrid one can see something of the Pacific Northwest, but much more of the prevailing tastes and interests of cultivated young Europeans in the last decade of the eighteenth century.

One catches the artists' excitement at the strange customs, costumes, and architecture of primitive man, and also their elation at finding themselves in a real-life Salvator Rosa landscape, with all its shaggy cliffs, tangled woods, blasted trees, and lurid skies. Rosa, the Sicilian baroque painter, was a great and much-imitated favorite in Georgian England, where the novelist Tobias Smollett called his work "dreadfully picturesque." So the young men had a fine time, in their journals and sketchbooks, with the granite precipices, waterfalls, and snowcapped peaks, as the land steepened around them along the Inside Passage.

Dread was in fashion in the 1790s, when the word "awful" still had a precise meaning, and images of the vertiginous crag, the dark forest, the storm at sea were calculated to induce a delicious sensation of vicarious terror. It happened that the Pacific Northwest was discovered by whites at the same moment as the idea of the Romantic Sublime was gaining sway. The lonely

and forbidding geography of the place perfectly fitted the reigning preconceptions of how a Romantic landscape ought to look. It conveniently combined, within a single view, the essential iconic features of the Swiss Alps, the German forest, and the English Lake District.

There was a single, unfashionable, dissenting voice—that of George Vancouver, known to his men (though never to his face) as Captain Van. At thirty-four, Vancouver was far behind his time. He was a provincial (from King's Lynn in Norfolk, where his father was employed by the Customs service); his education had been mostly acquired at sea (he'd been one of Captain Cook's midshipmen); and the sublime left him cold. His posthumously published *Voyage* gives a candid, heartfelt portrait of the Pacific Northwest as seen through the eyes of a young fogy who was out of touch with the intellectual currents of his own age.

Captain Van took a great shine to Puget Sound and its immediate surroundings. Among the low hills and forest clearings, he was able to imagine himself in a New Albion of close-shaven lawns, artful vistas, rolling fields, and country houses. Remembering the stretch of coast over which the retirement homes of Sequim are now sprawled, Vancouver wrote:

> *The surface of the sea was perfectly smooth, and the country before us exhibited every thing that bounteous nature could be expected to draw into one point of view. As we had no reason to imagine that this country had ever been indebted for any of its decorations to the hand of man, I could not possibly believe that any uncultivated country had ever been discovered exhibiting so rich a picture.*

But his pleasure in this newfound land soon curdled into repugnance as the expedition sailed north and west into the narrow, mountain-walled channels of the Inside Passage. While his juniors, along with the expedition naturalist, Archibald Menzies, thrilled to the dramatic sublimity of their surroundings, Vancouver recoiled from what he saw. The snowcapped peaks were "sterile," the cliffs of dripping rock and vertical forest were "barren," "dull," "gloomy," "dreary," "comfortless." Of the much-admired waterfalls, he complained that their incessant noise made it impossible for him to hear any birdsong.

Vancouver's voice seems to speak directly from the wrong end of the eighteenth century, when mountains were conventionally seen as rude geological excrescences: chaotic, useless, and offensive to the mind and eye ("vast, undigested heaps of stone," as Thomas Burnet described the Alps in 1681). Yet the real depth of feeling in Vancouver's grim and spiritually corrosive

landscape (whose epicenter he named Desolation Sound) is conspicuously lacking from most of the effusive paeans to the region's scenic grandeur. Captain Van ought to be adopted as the patron saint of all the Pacific Northwesterners who have felt walled in by their mountain ranges, or suffered a jolt of depression when faced by the black monotony of the fir forest under a low, wintry, frogspawn-colored sky.

The back-of-beyond aspect of the Pacific Northwest heightened its romantic allure. Even after the Oregon Territory came within reach of the enterprising tourist, Washington and British Columbia remained comparatively remote. The famously rough and grueling sea passage from Portland to Seattle was a serious deterrent, and it wasn't until James J. Hill's Northern Pacific Railway at last arrived at its Tacoma terminus in 1883 that Puget Sound became easily accessible to the casual traveler. In the meantime, a growing mystique attached itself to the area: people who'd never been there spoke of it as the last resort of unspoiled wilderness, romantic solitude, and wild indigenous inhabitants as yet unpolluted by white ways.

It was the Indians who drew the Irish-Canadian painter Paul Kane to British Columbia, Washington, and Oregon on a long and adventurous trip in 1846–47—though Kane's noble red men, discovered alone with their primeval forest and steam-belching volcanic cones, are disappointingly generic, and look as if they've stepped straight out of James Fenimore Cooper's *Leather-Stocking Tales*. What Kane's pictures celebrate is, rather, the intrepidity of the artist himself—the solitary white man out in the far West, ahead of the crowd, communing with primitive people in their natural state. His sketches and studio canvases document the progress of the artist as Romantic hiker-hero. Kane's journey is the real subject; his Pacific Northwest is an adequately wild backdrop for a sequence of pictures in which one's attention instinctively fastens itself less on the land than on the person of the painter.

In 1855, when George Catlin was pushing sixty, he stopped in the Northwest, breaking a voyage that took him from Cape Horn to the Bering Sea. At the mouth of Clayoquot Sound on the west coast of Vancouver Island—then as wild a site as any in the region—he sketched an extraordinary prophetic elegy on the fate of wilderness in an industrial, land-hungry age. *A Whale Ashore—Klahoquat* is as ambitious a painting as Catlin ever attempted—half moody seascape, half grim morality tale.

GEORGE CATLIN
A Whale Ashore—Klahoquat | *1855/1869*
oil on card mounted on paperboard, 18⅞ × 25¼"
Paul Mellon Collection, National Gallery of Art, Washington, D.C.
Photo: © 2000 Board of Trustees, National Gallery of Art

It's a troubled sunset over the Pacific, and the stranded whale is not the only creature in the picture that is seeing its last day. The Indians who swarm around the carcass, in canoes and on foot, are observed from such a distance that one can tell little about them except that they are members of the same species. They might just as well be a colony of prairie dogs. The swirling pattern made by the crowd on the beach has the organic coherence of a shoal of minnows or a flock of gulls.

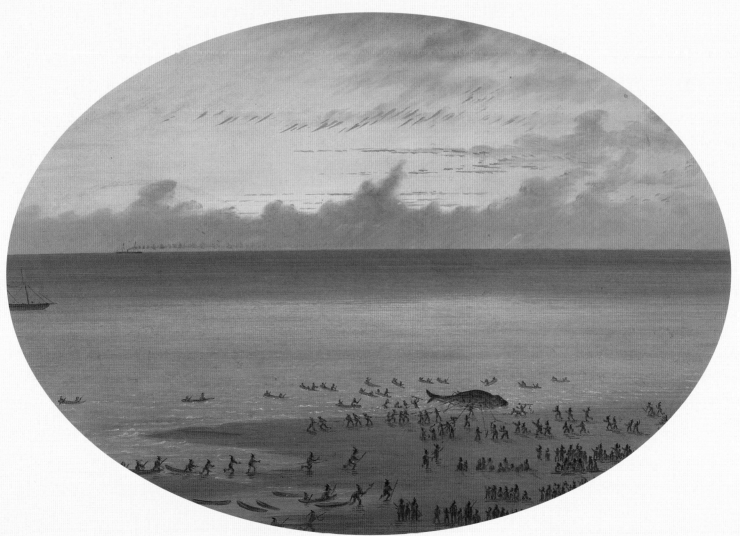

In the middle distance, a trim schooner rides at anchor. A boat has just put off from it. On the far horizon, to the right of the schooner, there is a flattened contrail of smoke from a steamship going south. Numerous as the Indians may appear, it's the braided smoke in the distance that holds the key to the inevitable outcome of this story. Historically speaking, we are just seconds away from the arrival of the logging crew, the pulp mill, the cannery, and all the rest of the machinery that will change forever the life of the unsuspecting people on the beach.

Since 1830, Catlin had been chasing Indians westward across the plains, trying to catch them before they were swamped by the tide of white conquest and settlement. By 1855, great tracts of the land that he had known as wilderness had been claimed for civilization by the plow and the fence. That Catlin could see the Indians as doomed even here, in the last outpost of the truly wild, reveals the depth of visionary pessimism that he had acquired on his travels. And he was right, of course. Ten years before he stood above the beach at Clayoquot, the Hudson's Bay Company had made Victoria their western headquarters; three years before, the Seattle city fathers had staked their claim to their settlement on Elliott Bay. Catlin's nearing steamship was as unstoppable as the setting sun.

The Indians in *A Whale Ashore* are squarely seen as part of the Pacific Northwest's nature, not its culture. It's no accident that one of the best collections of Northwest Coast Indian art is housed not in the National Gallery of Art in Washington, D.C., but in the American Museum of Natural History, where the Salish, Haida, and Kwakiutl tribes take their place alongside the stuffed bison and buffalo. In the basic grammar of nineteenth-century landscape painting, no stretch of Northwest water is complete without its canoeful of Indians—a native aquatic species whose presence gives the stamp of regional authenticity to the canvas. As the same water in real life filled with square-rigged lumber ships and steam tugs, its painted counterpart became an exclusionary zone from which white vessels were banished and only cedar canoes allowed.

In 1863, on his second swing through the West in search of material for his massive blockbuster pictures of the American Sublime, Albert Bierstadt planned to visit Puget Sound. His companion, the journalist Fitz Hugh Ludlow, fell ill in Oregon, and so the two men sailed instead from Portland to San Francisco, en route for New York. The unvisited territory evidently loomed large

in Bierstadt's imagination, and in 1870 he produced a curious painting entitled *Puget Sound, on the Pacific Coast* (page 30), in which he depicted a landscape of artistic myth and rumor, a Pacific Northwest *de l'esprit.*

By Bierstadt's seven-by-twelve-feet standards, the canvas is quite a modest one, but every last inch is packed to the bursting point with the stock ingredients of the sublime, all lusciously painted in Bierstadt's best show-off theatrical style. Here are rocks, precipices, withered trees, the darkness of a howling storm, a shaft of golden sunshine of the kind that might herald the Second Coming, a thunderous cascade descending a mountain face, a turbulent and angry sea, and Indians, hauling their canoes to safety out of the exploding surf. The picture turns Puget Sound into a brand name for the dreadfully picturesque.

More effectively than the Oregon paintings that Bierstadt drew from life, *Puget Sound, on the Pacific Coast* formulates the basic terms on which the Pacific Northwest made its appeal to the aesthetic tourist. The region was soon dotted with established vantage points offering painterly views of major landmarks—Mount Hood seen from the northwest bank of Lost Lake, Mount Adams seen from the Oregon side of the Columbia River, Mount Rainier seen from across Commencement Bay on Puget Sound. It was a quickly established convention that Northwest water—river, lake, or branch of the sea—was still enough to faithfully hold the reflection of a mountain for hours at a time. This despite Bierstadt's suggestion that Puget Sound waves break on the shore like those of the Mediterranean in a full gale.

Sanford Gifford, the luminist painter, and a close friend of Bierstadt's, was an early visitor. In 1874, he pitched his easel on what I take to be the beach on the southeast tip of Vashon Island, and painted Mount Rainier mirrored in the lakelike water of Commencement Bay (page 25); the snowcapped summit, rose-tinted in the light of a late summer afternoon, rises above a layer of hazy cloud like an apparition, or (in Gifford's own terms) a manifestation of the Divine. The water is made radiant by the diffused brilliance of the mountain's reflection. On the scored surface of the bay float two Salish canoes. On the far shore, the most prominent trees are as green and, more surprisingly, deciduous as any in Gifford's English and Hudson River landscapes. It's a picture of an undisturbed American Arcadia, in which Indians, their pathless woods, their peaceful water, and their inspiring alp, are seen to be living apparently beyond the reach of time.

It's Gifford's determined erasures that catch the eye. Gone (from the patch of land immediately above the canoe in the foreground) is the young town of Tacoma with its new lumber mill,

new docks, and fleet of moored cargo ships. Gifford's lovely Arcadia, so seemingly present, belongs to an imagined past, and the painting is suffused with nostalgia for a period that never really was, when bushy elms grew out over the water, and Indians were the nymphs and shepherds of European pastoral tradition.

Fifteen years after Gifford painted Mount Rainier, Bierstadt at last reached Puget Sound, after a painting tour of southeast Alaska. Camped out on what appears to be the same spot that Gifford had used for his view of the mountain, Bierstadt set to work. In 1889, Tacoma had grown to a smoke-and-steam-wreathed city of thirty thousand people. Bierstadt cancelled it from his vision. To accentuate the enchanted solitude of the scene, he painted in just one Indian canoe in place of Gifford's two.

It should not be thought that Bierstadt took no interest in the great industrial developments of his time. He was acutely sensitive to them. His major patrons were financial, timber, mineral, and railroad magnates, who bought Bierstadt's pictures (as they bought those of Thomas Moran)

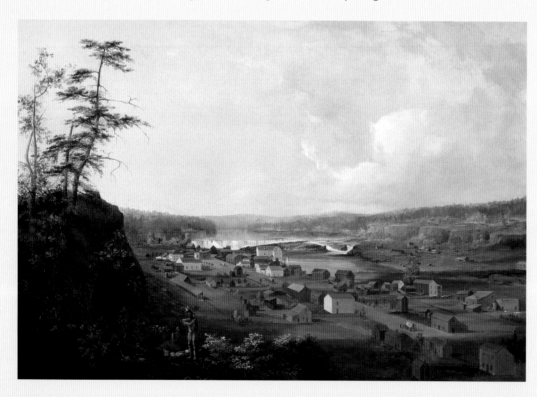

JOHN MIX STANLEY
Oregon City on the Willamette River | *c. 1850-52*
oil on canvas, 26½ × 40"
Amon Carter Museum, Fort Worth, Texas (1979.17)

as grandiose souvenirs of the West as it had been before their own work crews began to landscape it to the industrialists' design. When Bierstadt had finished his Rainier painting in his New York studio, he sent a hopeful letter to James J. Hill. Mount Tahoma (the alternative name for Rainier) was, he wrote, "one of the grandest of mountains," and it was happily situated "on the line of your road." The railroad baron didn't bite.

In a spirited counteroffensive to the idea of Manifest Destiny, the great mission of the Romantic painters was to depopulate the Northwest of all but its aboriginal inhabitants. It was left largely to amateurs, and, interestingly, to painters of Indian scenes like Catlin and John Mix Stanley, to tell the other side of the story. No one had a keener sense of the fantastic pace of white industry and settlement than the artist who spent his life searching for authentic Indians in the ever-decreasing wild.

Though John Mix Stanley specialized in Indian portraits, he was an accomplished, if conventional, landscape painter. His 1850s picture, *Oregon City on the Willamette River*, is a conspicuously fair-minded treatment of the theme. The sublime survives in the immediate foreground, where a bluff overlooks the Willamette Valley, but it has mostly been exiled to the back of the canvas, where sandstone cliffs and thick forest frame a splendid riverwide waterfall. Sandwiched between wilderness in the distance and wilderness nearby lies an infant city of neat rectangular plots and newly painted houses, dominated by an English-style church and a three-story sawmill. Covered wagons are rolling down Main Street. The low light is falling from the east; it's early morning, and this is just the beginning of what is going to happen to Oregon in the near future.

Cut to the figures on the bluff, still in shadow, for the morning hasn't reached them: two Indians, a man and a woman, with what looks like a bedroll between them. The man is leaning on a staff, so he's a pilgrim, or a vagrant. Both figures look directly at the viewer. They might be homeless people on a modern street, begging passersby for change.

With hindsight, we know where the couple are headed. In 1857, Stanley painted an allegory titled *Last of Their Race* in which ten Indians, wearing the costumes of different tribes, are found perched on a pile of rocks at the edge of the Pacific Ocean, their last toehold on the West that once used to be their domain.

Yet Stanley's rendering of the fatal city is so affectionately drawn that the painting seems to shimmer with ambiguity, like a hologram changing shape as it tilts under a light. Now you're with the Indians, now you're with the whites. At first glance the picture looks like an advertisement for the civic pleasures that await the traveler at the end of the Oregon Trail; it promises space to build and breathe amid tranquil natural surroundings—a school for your children, a waterfall to delight your eye. At second glance, that cheerful promise seems callow and heartless—but not so callow or so heartless that it cancels out one's first impression. As with the hologram, both images are equally there, but never quite at the same time.

An amateur, Emily Inez Denny, a member of one of Seattle's founding families, takes the robust, monocular view of settlement in a painting of Smith's Cove on Elliott Bay done in the 1880s. The artist is positioned in the middle of a stump-field where timber is being logged to make way for future development. (The space just behind her will turn, eventually, into a chain-link-fenced compound for imported Japanese cars, fresh out of their containers.) Ahead of her lie the already-substantial accomplishments of her ingenious, hardworking family and friends: the handsome homestead with barns, outbuildings, and orchard; ships, under steam and sail, in the harbor; a locomotive hauling a line of cars on the railroad that is carried on trestles over the shallows at the north end of the bay; two horse-and-buggy outfits headed into town down the southeast-trending lane. The whole sky is dominated by a roiling billow of steam issuing from the impossibly tall smokestack of a mill somewhere over on Vashon Island, or beyond.

Emily Denny's picture, with its proud detailing of modes of transportation, makes that most poignant of provincial boasts: we may seem to live miles from anywhere, but we are really *very* well connected. In that respect, her painting is bang up to date, 120 years later.

She belongs to a vernacular landscape tradition, with the picture-postcard photographers of the Pacific Northwest. The photographers used many of the same views and vantage points as the painters, but these coincident locations serve only to expose the huge rift between their contesting visions of the land.

The turn-of-the-century postcards abhor solitude. They represent nature as a resource, for industry and recreation. One wonders what Bierstadt, for instance, would have made of the diagonal line of twenty-five people "nature coasting" down a snowy slope of Mount Rainier and waving to the camera as they slide by. Every river has its fisherman, every lake shore has its picnic table. A postcard from Oregon shows Mount Hood mirrored in Lost Lake, a favorite view of the

EMILY INEZ DENNY (ATTRIBUTED)
Untitled (Panoramic view of Smith's Cove) | *c. 1880s*
oil on canvas, 20¹⁄₁₆ × 36¹⁄₁₆ "
Museum of History and Industry, Seattle
Photo: Howard Giske

painters, but here a man in a bush hat sits in the foreground, cradling a gun, as if he were about to unzip the reflection with a bullet. Mountain scenes afford a pretty backcloth for early Oldsmobiles and Fords, shown parked on dirt tracks in the heart of the Romantic Sublime.

As the postcards promoted the luxury hotels, parks, zoos, and electric-lighting of the new cities, so they took a boosterish line on the sources of the cities' wealth. Loggers are represented as gnarled western heroes, widely grinning from halfway up the trunk of some monarch of the forest, which they are just about to ignominiously dethrone. Massive baulks of cut timber, a hundred feet long and seven feet square, are captioned "Washington Tooth Picks." A class of

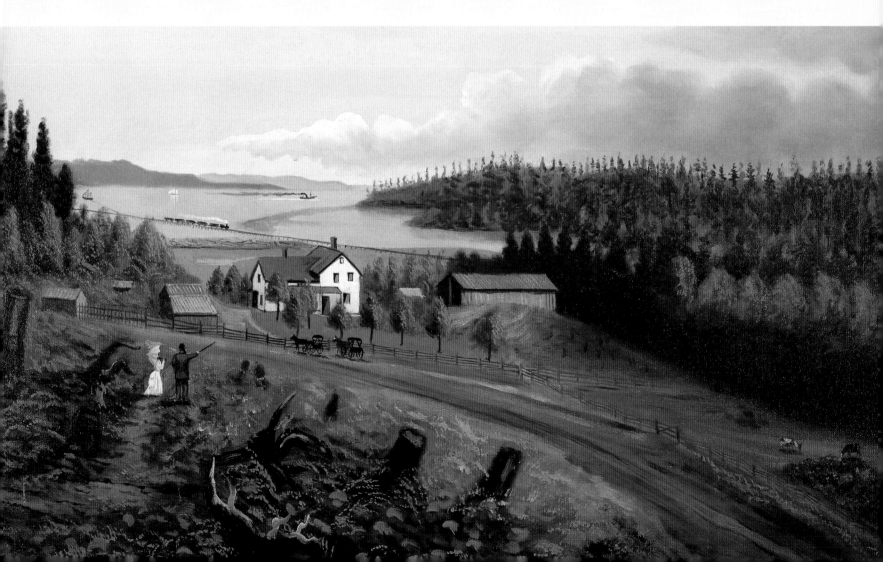

twenty-six grade-school children is shown sitting atop the flat stump of a single logged cedar. Bridges, shipping, farms, mills, and railroads figure in the postcards as triumphs of civilization over the wilderness—a wilderness which, by 1905 or thereabouts, could already be thought of as a lavish extension of a civic park, to be measured in terms of its multitude of facilities for tourism and sport.

One postcard from a later date—circa 1950—qualifies as one of the few essential iconic Northwest landscapes. It shows the vast glaciated extrusion of Mount Rainier, grandly outclassed by a B-17 Flying Fortress that appears to be cruising directly over the summit. Here is the awe-inspiring, Seattle-manufactured technological sublime, putting nature in its place. The dormant volcano and the Boeing bomber are up to the same deadly waiting game. This was the card to send, with love, to Moscow.

The most powerful and dramatic landscapist of the Northwest was the timber industry, which turned the forested mountainsides into a new kind of wilderness of skid roads, stumps, and slash. I saw my own first clearcut eleven years ago, when I was out here on a visit. It was unexpectedly stirring to see the sheer totalitarian scale of damage that the chainsaw can inflict, and the sight ranks in memory somewhere alongside my first view of the Manhattan skyline, or the Pyramid of Cheops, as one of the great eccentric wonders of mankind. I understand perfectly why Paul Bunyan was one of the main mythological gods in the American pantheon, before his activities came to be regarded as being on a level with spilling oil and dumping untreated sewage.

No sooner had the Pacific Northwest been established as the last outpost of the Romantic Sublime than it was recast as a battlefield in the war between man and nature. The loose group of Seattle-based painters whom *Life* magazine would, in 1953, label as the Northwest School (Morris Graves, Mark Tobey, Guy Anderson, Kenneth Callahan) lived within view of the clearcuts. If their best-known work leans toward the calm restraint and stylization of Japan and Zen Buddhism, that may be—in part, at least—a response to the violence and upheaval that figure so prominently in most of their early paintings. Against Graves's later, light-infused and delicate studies of birds, animals, and potted plants should be set his *Logged Mountains* painted in 1935–43 (page 66).

KENNETH CALLAHAN
Northwest Landscape | *1934*
oil on board, 34 × 47"
Seattle Art Museum, Eugene Fuller Memorial Collection
Photo: Paul Macapia

The upstanding dead and withered trunks left by the loggers are identical twins to the light-ning-blasted trees to be found in the spooky landscapes of Salvator Rosa, like *Mercury and the Dishonest Woodman* and *Landscape with Tobias and the Ange* (both in the British National Gallery in London). But they are the least of it. The land itself has turned into liquid slurry; it's pouring, in a viscous, yellowish-greenish waterfall, right through the bottom of the painting. The idea of the grand cascade—central to Romantic pictures of the Northwest in the nineteenth century—has here become perverted into a Niagara of waste. The draining land leaves behind bare chunks of rock, like rotten molars, under a sinister and stormy sky. The dominant colors—russet, ocher, greens that verge on black—are the true colors of Washington, as seen by an unillusioned resi-dent, and not by a tourist like Sanford Gifford.

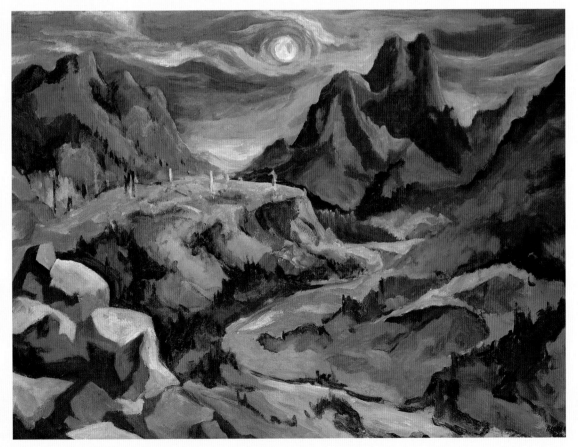

Graves is only describing what actually happens when a mountain is indiscriminately logged and its drainage system wrecked: it turns into a mudslide. His landscape—as dreadful as anything conceived by the Romantics—is based on close natural observation. Similarly, *House in a Landscape* (circa 1930s), his exquis-itely precise depiction of a collapsing homestead, its timbers warped and splayed as the house melts back into the earth, is at once a bold statement about the decay of human hopes in an unkind land and a cool exercise in pure draftsmanship. In both paint-ings, one feels Graves's keen intimacy with his region and its areas of dark-ness. This is a Northwesterner's bleak version of the Northwest—and it is lit-tle wonder that Graves later escaped

into the light and airy simplicity of his post-1960s work. It's not for nothing that rainy Seattle leads the country in the per capita sale of sunglasses.

The response to the clearcuts made by Graves's friend and colleague Kenneth Callahan was a sequence of big, almost Bierstadt-sized canvases that tip their caps ironically at the Romantic Sublime. Same mountains, same rivers, same forest— except that the forest has been stripped from the picture, and the landscape rendered in a monochromatic muddy brown and littered with the machinery of the timber industry, so that it recalls a strange, alpine version of the battlefields of the Marne and the Somme. You might expect to see the tin hats of dead soldiers hung on the crosslike projections of Callahan's surviving stumps.

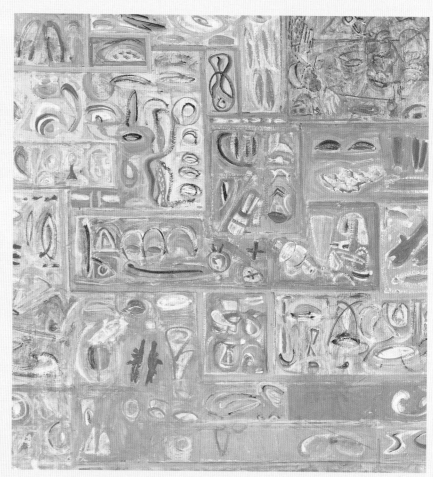

In the 1940s, before he entered his squiggly, Zen-inspired, drip-painted white-writing phase, Mark Tobey was playing close attention to the art of the Northwest Coast Indians, as in his *Drums, Indians, and The Word* (1944). Since John Webber first sketched at Nootka, Indians had always been in the foreground of Northwest landscapes, as the obligatory *genii loci* of the region, but their art had made only incidental appearances, in the form of the carved and painted canoe, house post, totem pole, and embroidered hat. The rediscovery of primitive art was on the core curriculum of twentieth-century modernism, with Braque and Picasso rivaling each other in their extensive collections of Amerindian and Pacific-island trophies. Borrowing from the stylized and abstracted vision of the world as it was represented in tribal art became a modernish mannerism; and on the Northwest Coast, the white artist had immediate access to an extraordinary body of native work. The art of the Kwakiutl, Haida, Tsimshian, and Tlingit Indians was as vital, strange, and complex as any in the world. On bentwood boxes, muslin wall hangings, house fronts, masks, and

domestic equipment, the Indians had left their own—often highly enigmatic—landscapes of the Pacific Northwest: a great treasury of techniques and images to which twentieth-century white artists began to freely help themselves.

Tobey, like Morris Graves (who took on Oregon), accepted a commission to paint Washington in the *United States Series*, funded between 1946 and 1949 by the Container Corporation of America. Graves's *Oregon* was a delicate, feathery, Japanese-looking study of Northwestern evergreens. Tobey's *Washington* was an intensely busy, Indian-inspired pictographic puzzle, like the totemic heraldry on a Kwakiutl painted chest.

It's a labyrinth of interlocking rectangles, each one packed with images and symbols, on a ground as luminously gray as a Seattle sky. Inside the rectangles are to be found dozens of "ovoids" or "eye-shapes"—the basic building blocks of Northwest Coast Indian design. As with the Kwakiutl chest, the painting demands to be "read" by the viewer, and as with the chest, some of its meanings readily disclose themselves while others appear to be deeply secretive and private. You see immediately the salmon, the Pike Place Market scene, the seascape with a sailboat, the tribal masks, but the larger code is not so easily cracked. On one level, the painting resolves into a game of *Can you spot?* (. . . the killer whale? canoes? logs? mountains? Indian bird-rattle? Skagit Valley tulips? the artist in his studio? the oyster? clams?) On another, it's a palimpsest of writing-on-writing: some legible and strongly foregrounded, some faint and obscure, with the whole composition giving the impression of infinitely recessive depth. More than any other painting in the Container Corporation's series, Tobey's *Washington* succeeds in condensing an entire American state, its nature, industry, and recreations, down to a square of paperboard; and it does so by summoning the aid of the state's aboriginal inhabitants, whose own art forms the whole conception of the piece.

It was Tobey who nagged at Emily Carr, the British Columbian painter, to get the Indian folkloric material out of her pictures. After training in Paris, where she fell for the work of Derain and the Fauves, and a long spell in an English mental hospital, where she filled an aviary with British songbirds, hoping to import them to Vancouver Island, Carr traveled through coastal B.C., painting Indian canoes, house posts, and totem poles in the forest. In 1930, when he was forty and she was fifty-nine, Tobey appointed himself as Carr's mentor and critic, advising her to drop the Indian subjects and follow his lead into greater abstraction. The famously spiky Carr was not a natural follower. "Clever, but his work has no soul," she remarked of Tobey in her journal.

MARK TOBEY
Washington (United States Series) | *1946*
gouache on paperboard, 24 × 22"
Smithsonian American Art Museum, Washington, D.C.

Though Tobey's opinion of her work rankled, it evidently found its mark, for the canoes and totem poles began to disappear from Carr's canvases, allowing the turbulent shapes of the forest itself to emerge as her great subject. Before, she had concentrated on recreating, in two dimensions, the swooping curves and expressive distortions of carved figures like Raven and Thunderbird. After about 1930, the foliage of the fir forest and its undergrowth of bracken, blackberry, and salal became a kind of painted sculpture in its own right. Every leaf and twig looks chiseled, in Indian house-post style, and Carr's forest is thick with fortuitous visual echoes of the mythological creatures who dominated her earlier paintings—especially Dzonogwa, the female Kwakiutl child-stealer, Raven, and Eagle. This is animist nature—a realm of gross and copious fecundity, where powerful half-seen beings live in the shadows.

In her journal (published posthumously as *Hundreds and Thousands*), Carr took a dim view of people who "stay outside [the forest] and talk about its beauty":

> *Nobody goes there. Why? Few have anything to go* for. *The loneliness repels them, the density, the unsafe hidden footing, the dank smells, the great quiet, the mystery, the general mix-up (tangle, growth, what may be hidden there), the insect life. They are repelled by the awful solemnity of the age-old trees, with the wisdom of all their years of growth looking down upon you, making you feel perfectly infinitesimal—their overpowering weight, their groanings and creekings [sic], mutterings and sighings—the rot and decay of the old ones—the toadstools and slugs. . . .*

If this passage is at least as much about the dank and smelly mystery of sex as it is about trees, so are Carr's paintings—though the explicit sexuality of her forest is far from being its only signification. In August 1937, she wrote of an unfinished picture of the woods, "It all depends on the sweep and the swirl and I have not got it yet." In her best paintings, the forest is literally a whirlpool of meanings, in a state of constant dissolution and recombination. Sex is to be found there, but so are worship, peaceful refuge, fear, revulsion, beauty, power, pathos. It's a complex and accommodating place that answers equally to, say, George Vancouver's desolation and the Romantic sense of wonder. It seems as close as any white artist or writer has ever approached to the Indian version of the Northwest forest as it appears in the native stories collected by early anthropologists such as Franz Boas.

MICHAEL BROPHY
People's View | *1999*
oil on canvas, 78 × 96"
Courtesy of Linda Hodges Gallery, Seattle

The Pacific Northwest is now entangled in a rancorous quarrel about landscape. "Wise use" has become the sly euphemism for chainsaw-liberation. Farmers rally to protest the reintroduction of the wolf into the mountains; salmon-first conservationists plan on dynamiting the hydroelectric dams about which Woody Guthrie used to sing.

Here's a contemporary Pacific Northwest landscape: On the Olympic Peninsula, the corpse of a northern spotted owl was found nailed to a fence post. The bird had been expertly shot with a high-powered small-caliber rifle. Beside it was pinned a typewritten note or caption: "If you think your parks and wildernesses don't have enough of these suckers, plant this one." The anonymous artist left behind two beer cans, a Band-Aid, and a spent match.

This stretch of land has been so fought over, painted and repainted, laden with partisan and contradictory meanings, that it tends to invite the response of a tired postmodern shrug. A recent *New Yorker* cartoon by David Sipress shows a vacationing couple standing beside their RV atop a dizzy precipice, from which they're looking down at the usual natural amenities of the Pacific Northwest—fir trees, mountains, waterfalls, winding trails, et cetera, et cetera. The man, in baggy tartan shorts and wraparound sunglasses, is saying to the woman: "So this is the famous environment everyone's so hyped up about?"

It's "the famous environment" that the Portland artist Michael Brophy depicts with sardonic cool. At the turn of the twenty-first century, Brophy has achieved in *People's View* the ambition of every nineteenth-century Romantic painter: he has voided the land of its people. Not even a solitary Indian disturbs his denuded Northwest, with its lonely geology, water, and dark green vegetation—though field lines and bridges still survive, and the hills have been largely shorn of their timber. Nature (or what little is now left of nature) has become a prettily-lit stage set, from which the audience has been divorced by a proscenium arch. In the immediate foreground of the picture, the spectators are assembled, their backs to the painter: a dense crowd of urban types, in Birkenstocks and earth-toned leisurewear from Eddie Bauer. We're in there too, dutifully gazing at this empty spectacle, this picture of a picture, which is what the Pacific Northwest has become. We're in exactly the same position as the people who look at the sea in the poem by Robert Frost:

> *They cannot look out far.*
> *They cannot look in deep.*
> *But when was that ever a bar*
> *To any watch they keep?*

Pacific Northwest Landscape Paintings

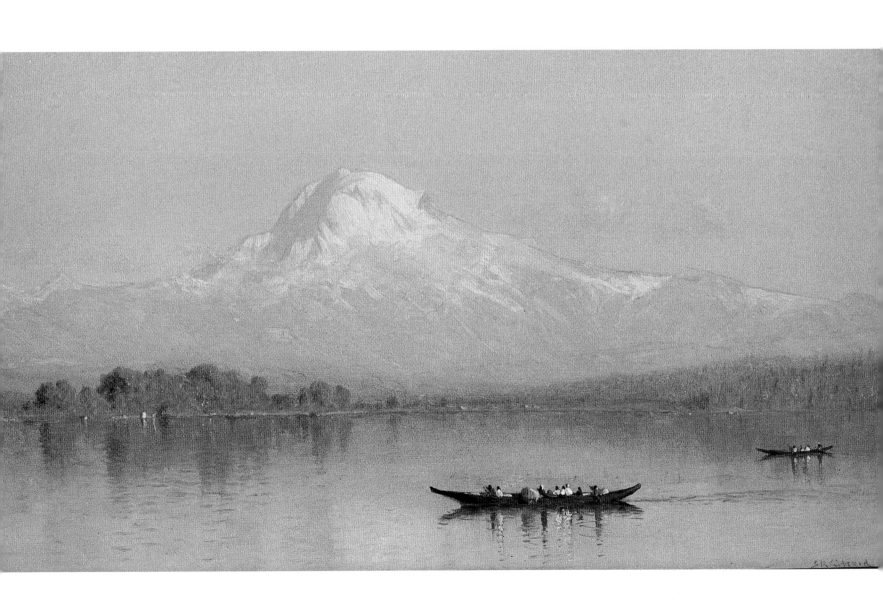

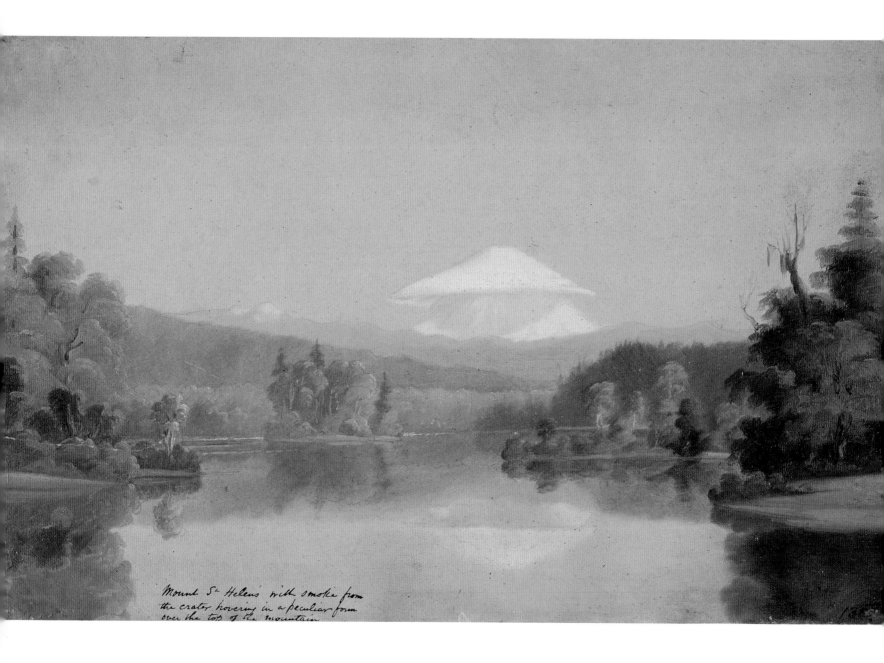

Mount St Helens with smoke from
the crater hovering in a peculiar form
over the top of the mountain

LEFT:

PAUL KANE
Mount St. Helens with Smoke Cone | *1847*
oil on paper, 8⅛ × 13⅜"
Stark Museum of Art, Orange, Texas

BELOW:

PAUL KANE
Kettle Falls, Fort Colville | *1847*
oil on paper, 8⅛ × 13⅜"
Stark Museum of Art, Orange, Texas

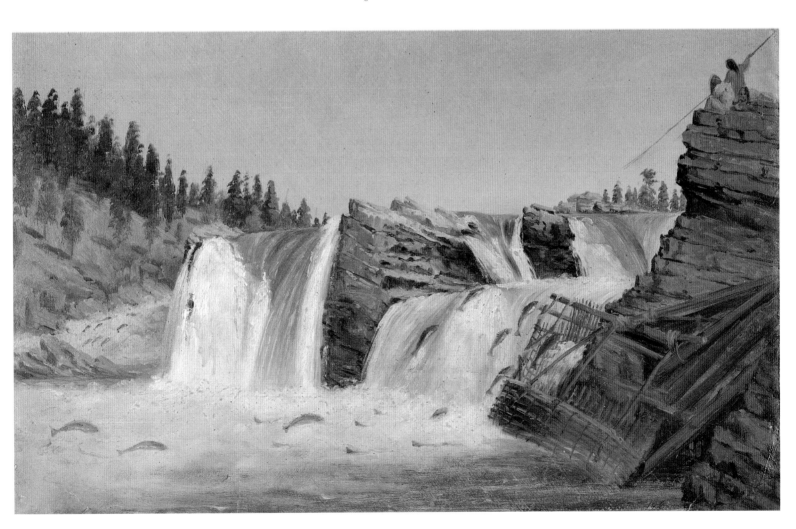

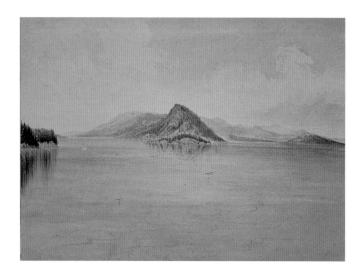

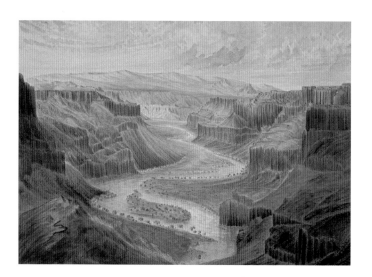

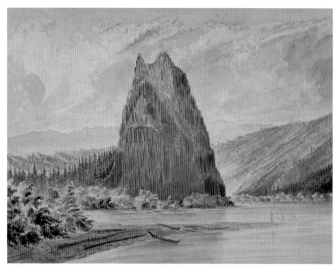

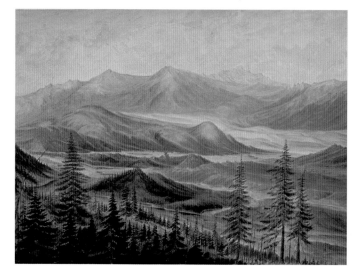

JAMES MADISON ALDEN
UPPER LEFT:

Straits of Haro. Stewart's Island in centre | *c. 1858*
watercolor
National Archives, Washington, D.C. (76-E221-3)

ABOVE:

Castle Rock, or McLeod's Castle. Right bank of Columbia River | *c. 1858*
watercolor
National Archives, Washington, D.C. (76-E221-12)

UPPER RIGHT:

Canyon of Palouse River looking South from a point just below the falls | *c. 1858*
watercolor
National Archives, Washington, D.C. (76-E221-15)

ABOVE:

Kootenay River. Junction with Elk River. View from trail on right bank (detail) | *c. 1858*
watercolor
National Archives, Washington, D.C. (76-E221-36)

W. G. R. HIND
Foot of Rocky Mountains | *1862*
watercolor, 8½ × 12"
McCord Museum of Canadian History, Montreal (M466)

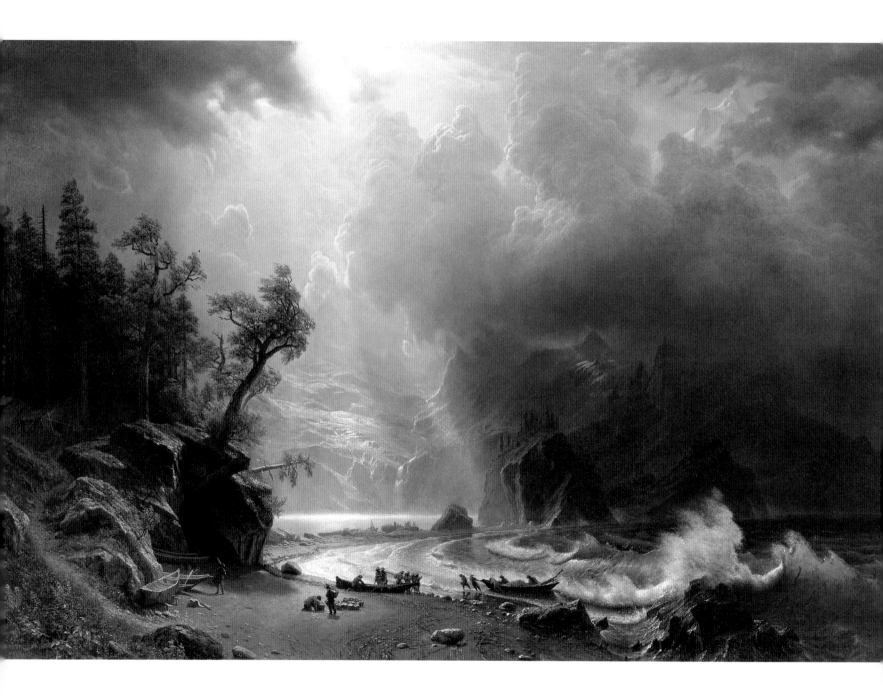

LEFT:

ALBERT BIERSTADT
Puget Sound, on the Pacific Coast | *1870*
oil on canvas, 52½ × 82"
Seattle Art Museum. Gift of the Friends of American Art at the Seattle Art Museum
with additional funds from the General Acquisition Fund
Photo: Howard Giske

BELOW:

WILLIAM SAMUEL PARROTT
The Three Sisters from Clear Lake | *c. 1880*
oil on canvas, 24 × 36"
Counting Eagles Collection, Portland

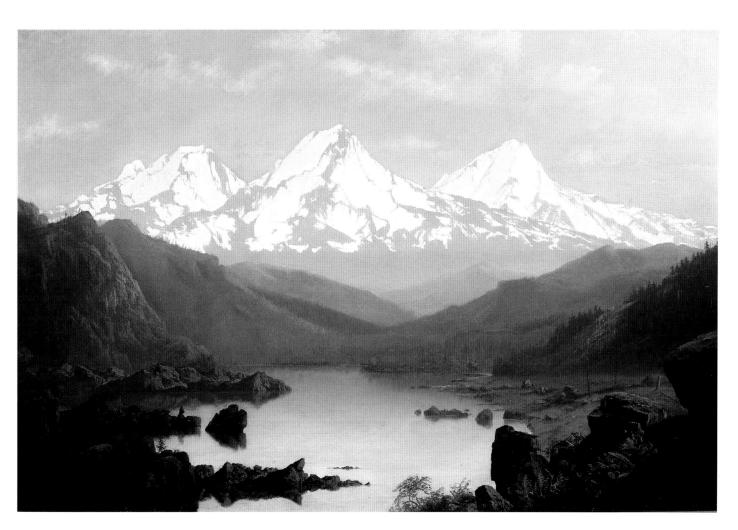

RIGHT:

CLEVELAND ROCKWELL
Early Morning, View of Tongue Point from Astoria | *c. 1883*
watercolor, 13¾ × 19¾"
Columbia River Maritime Museum, Astoria, Oregon

BELOW:

GRAFTON TYLER BROWN
Mt. Hood from John Day's Station | *1884–85*
oil on canvas, 16 × 26"
Collection of Professor and Mrs. David C. Driskell.
Courtesy of Braarud Fine Art, La Conner, Washington

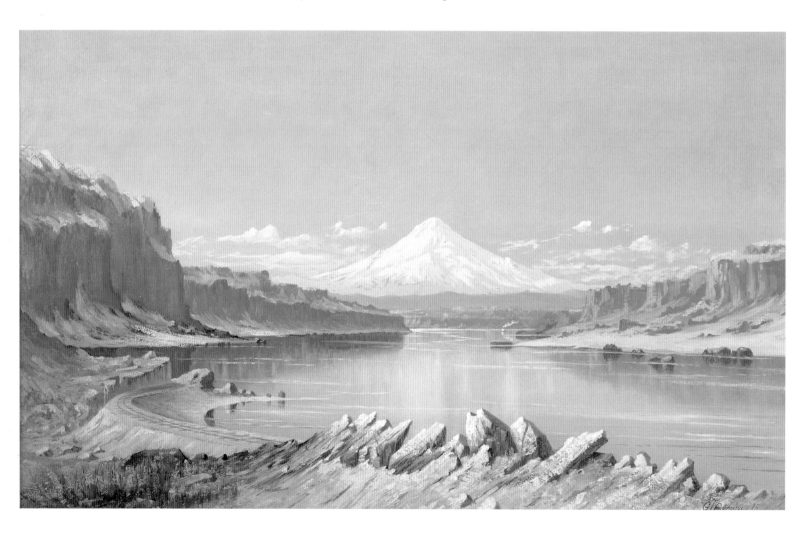

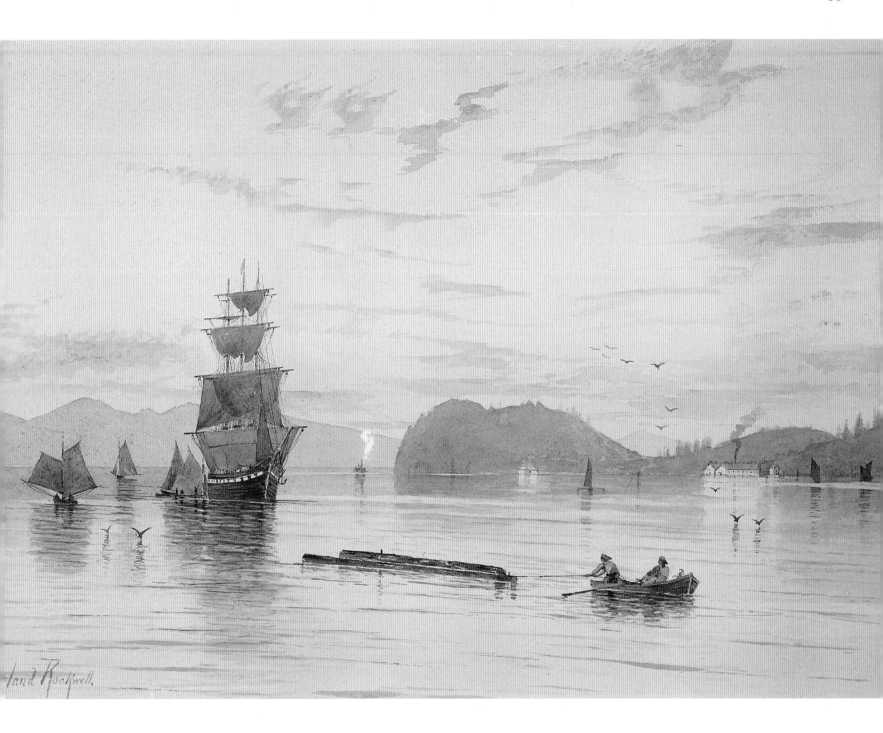

RIGHT:

THOMAS HILL
Mt. Hood | *1880*

oil on canvas, 14 × 22"
Private collection. Courtesy of Braarud Fine Art, La Conner,
Washington

BELOW:

CLEVELAND ROCKWELL
The Weather Beach | *1884*

oil on canvas, 20 × 34"
Private collection. Courtesy of Braarud Fine Art, La Conner,
Washington

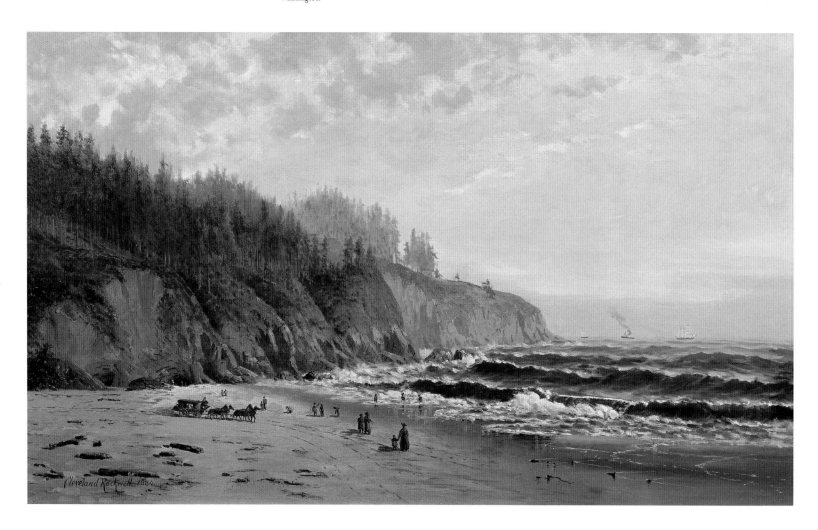

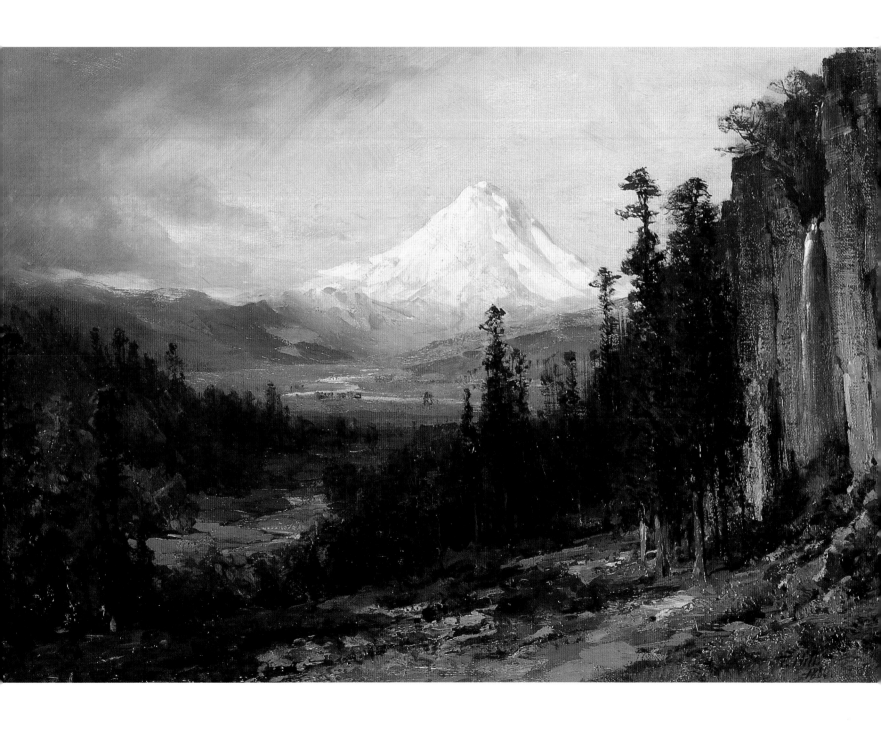

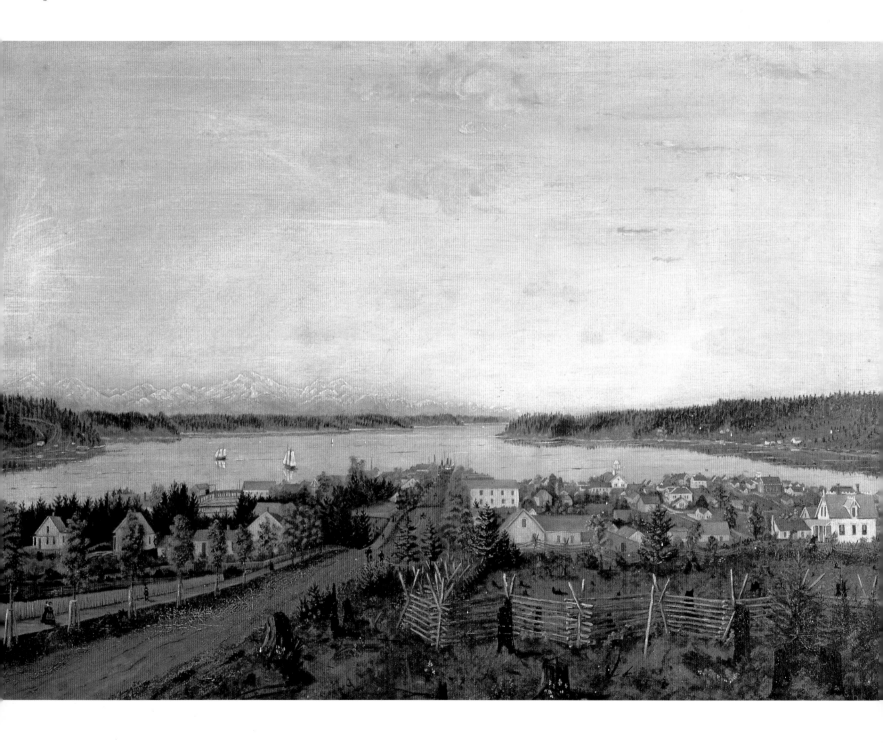

LEFT:

EMILY O. KIMBALL
Untitled (Olympia, Budd Inlet, and the Olympics) | *1872*
oil on canvas, 19¼ × 27"
Washington State Historical Society, Tacoma, Washington

BELOW:

ARTIST UNKNOWN
Untitled (Willamette River scene) | *c. 1870s*
oil on fiberboard, 23 × 33½"
Collection of Wallace Huntington

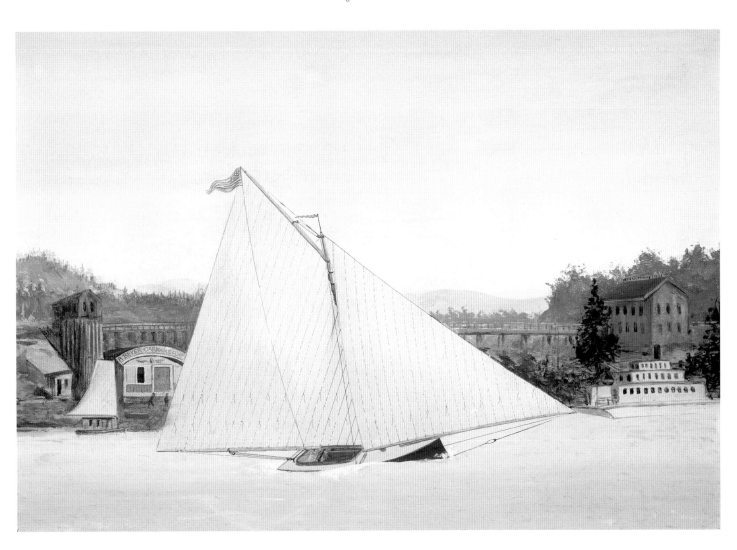

RIGHT:

B. J. HARNETT
Untitled (Seattle Fire and Mount Rainier) | *1889*
oil on canvas, 22³⁄₁₆ × 36³⁄₁₆"
Museum of History and Industry, Seattle
Photo: Howard Giske

BELOW:

JAMES EVERETT STUART
Mt. Baker from near Port Townsend | *1885*
oil on canvas, 24 × 48"
Whatcom Museum of History and Art, Bellingham, Washington.
Courtesy of Braarud Fine Art, La Conner, Washington

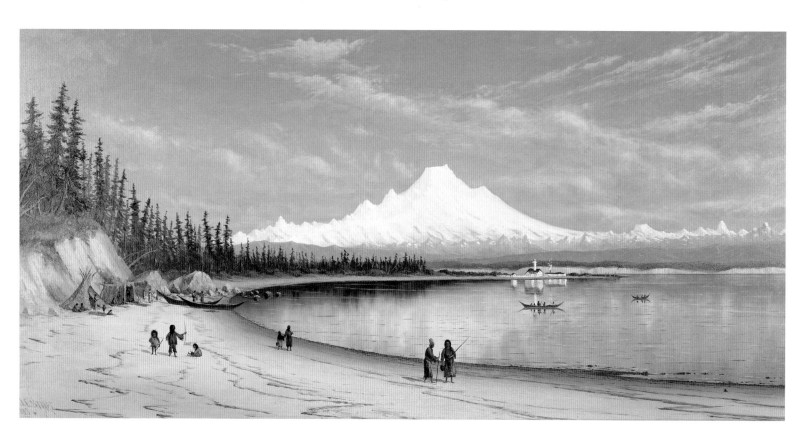

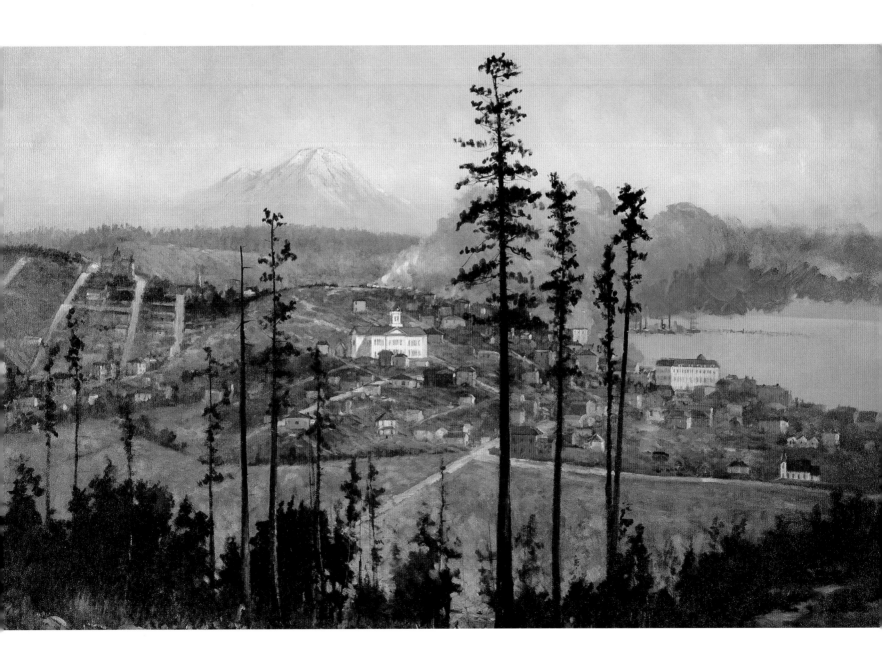

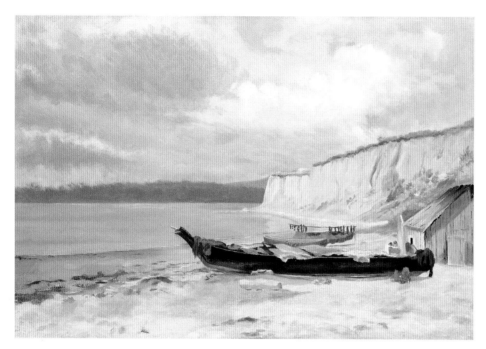

LEFT:

HARRIET FOSTER BEECHER
Port Townsend | *c. 1890*
oil on canvas, 14¹⁄₁₆ × 20"
Museum of History and Industry, Seattle
Photo: Howard Giske

RIGHT:

HARRIET FOSTER BEECHER
Untitled (Puget Sound near Port Townsend) | *1888*
oil on paper, 13⅝ × 19¾"
Museum of History and Industry, Seattle
Photo: Howard Giske

BELOW:

JOHN FERY
Untitled (Seattle waterfront with Indian canoes) | *c. 1910*
oil on canvas, 21⅞ × 35⅞"
Museum of History and Industry, Seattle
Photo: Howard Giske

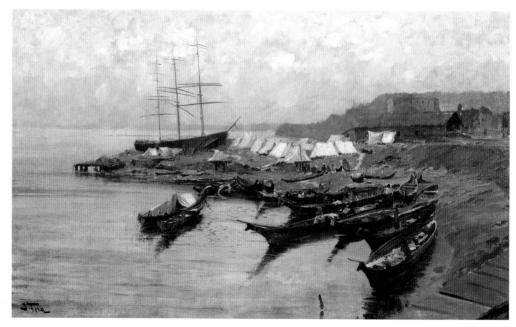

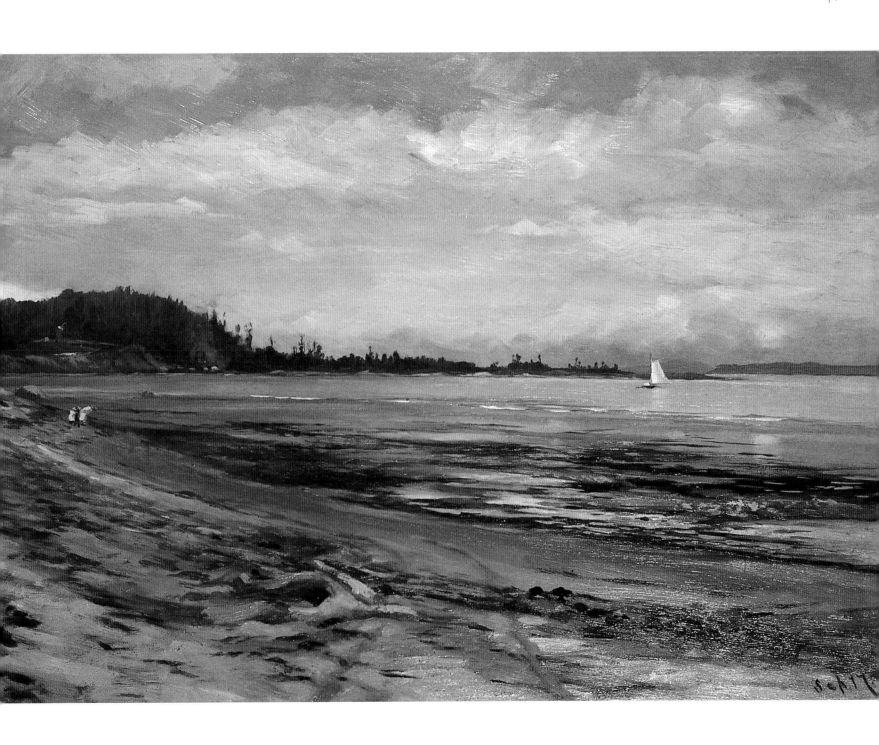

RIGHT:

GEORGE BICKERSTAFF
Mountain Sunset (Olympic Range) | *c. 1925*
oil on canvas, 24 × 30"
Private collection. Courtesy of A. J. Kollar Fine Paintings, Seattle

BELOW:

WILLIAM SAMUEL PARROTT
Crater Lake | *c. 1890s*
oil on canvas, 24 × 30"
Collection of Mark and Gay Santos, Santos Gallery, Portland
Photo: Mark Santos

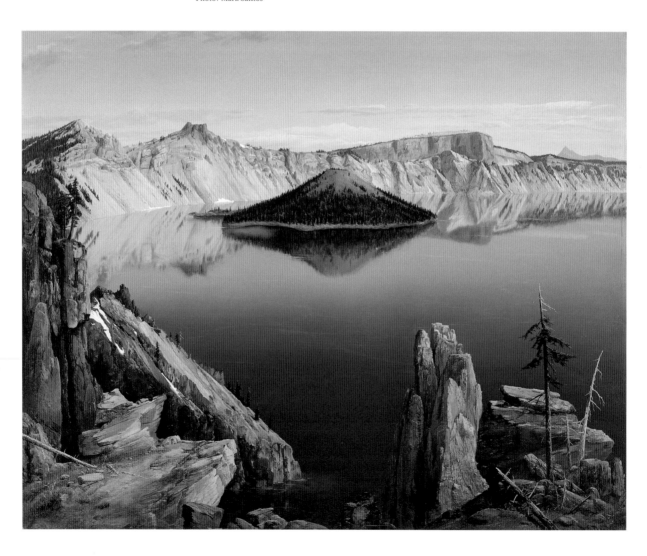

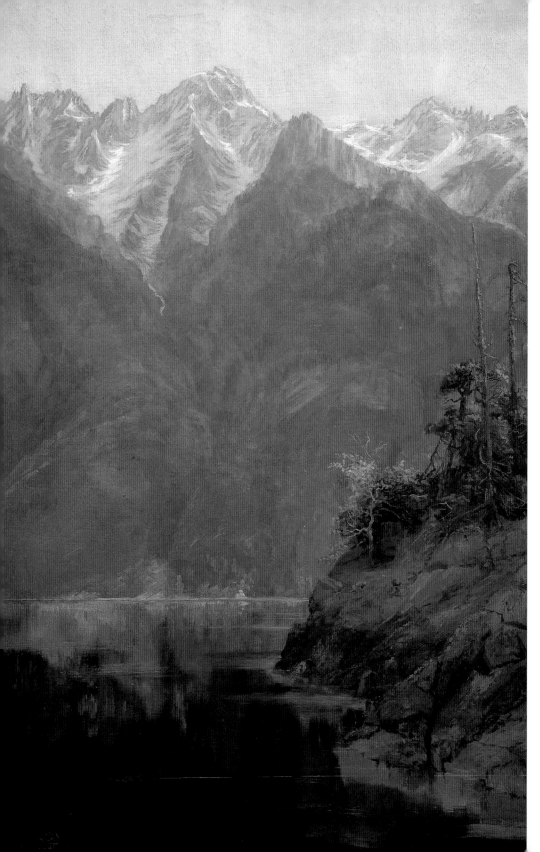

LEFT:

ABBY WILLIAMS HILL
Looking Across Lake Chelan | *1903*
oil on canvas, 25 × 28"
Collection of the University of Puget Sound, Tacoma, Washington

RIGHT:

PAUL MORGAN GUSTIN
Mount Rainier | *1907*
oil on canvas, 36½ × 47½"
Collection of the Rainier Club, Seattle
Photo: Richard Nicol

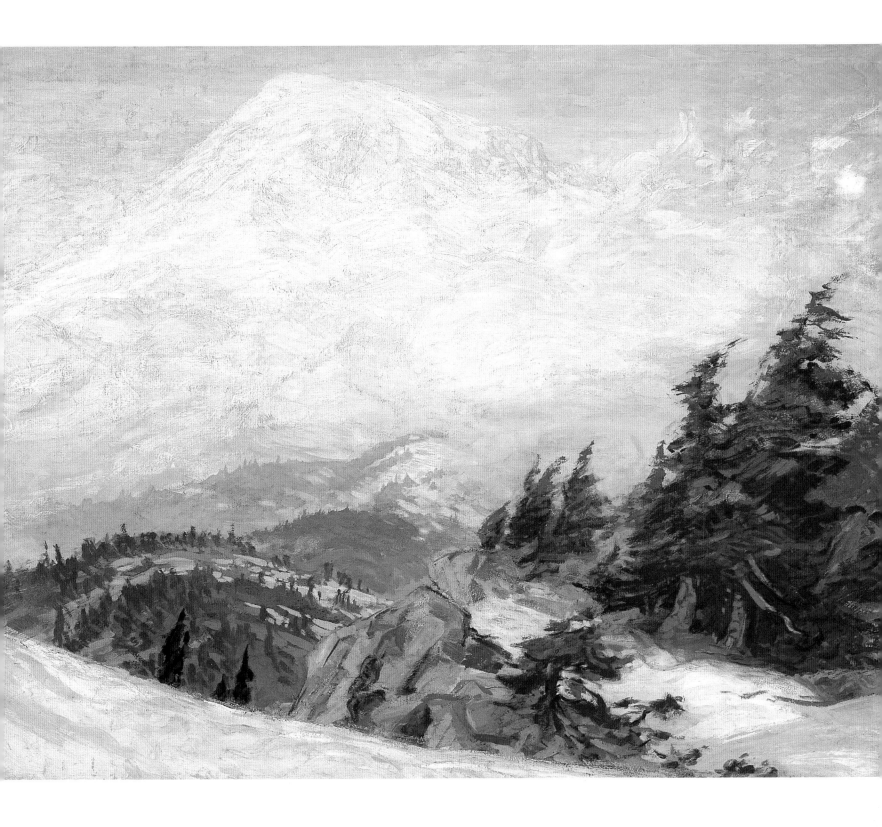

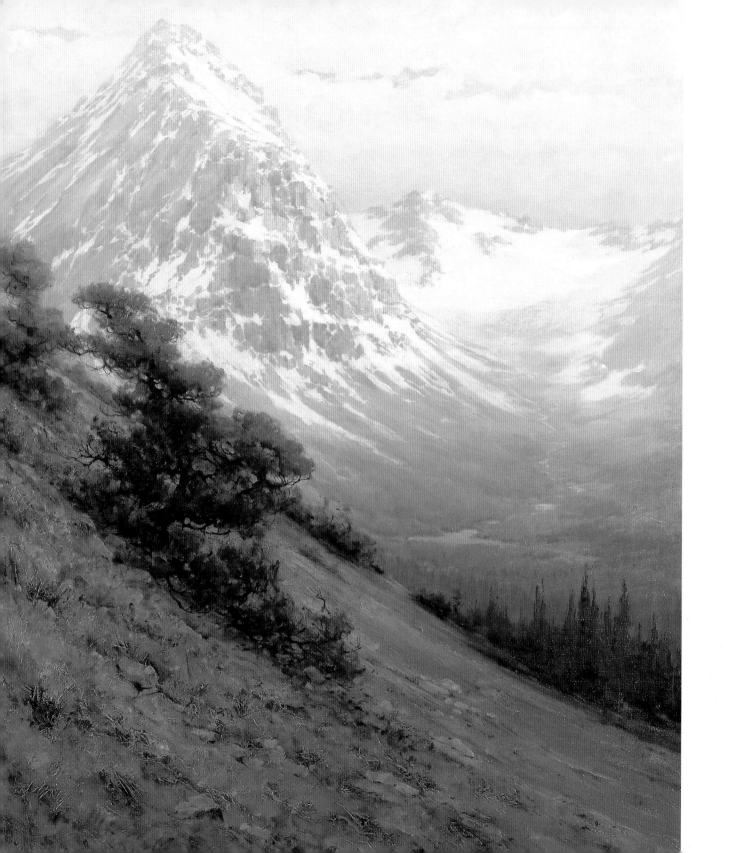

LEFT:

LOUIS B. AKIN
Osborns Pass, B.C. | *1909*
oil on canvas, 36 × 30"
Private collection. Courtesy of Braarud Fine Art, La Conner, Washington

BELOW:

SPENCER PERCIVAL JUDGE
Vancouver from Deadman's Island | *1919*
watercolor, 10½ × 19¾"
Private collection. Courtesy of Heffel Fine Art Auction House, Vancouver, B.C.

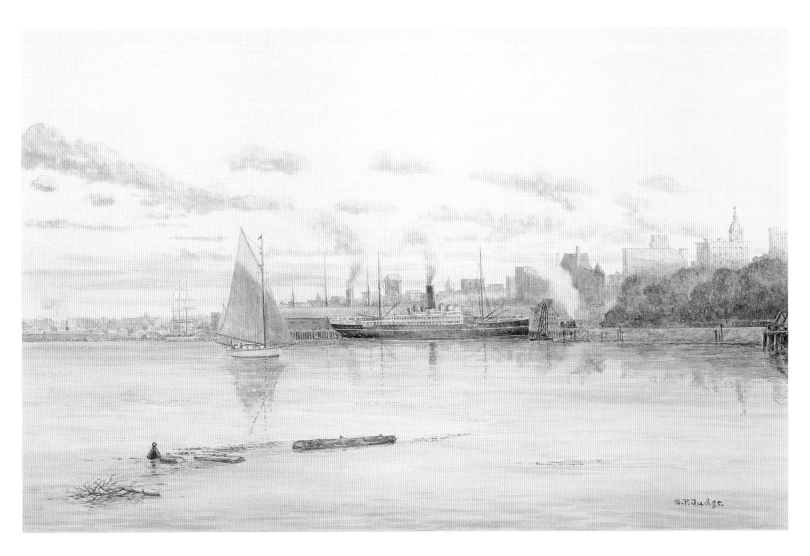

LEFT:

CLARA JANE STEPHENS
Yamhill Street, Early Twilight | *c. 1915*
oil on canvas on board, 9¾ × 13¼"
Collection of Robert Lundberg

RIGHT:

FOKKO TADAMA
Untitled (Pike Place Market scene) | *c. 1915*
oil on canvas, 16 × 21"
Collection of Mr. and Mrs. John Holland. Courtesy of
Martin-Zambito Fine Art, Seattle

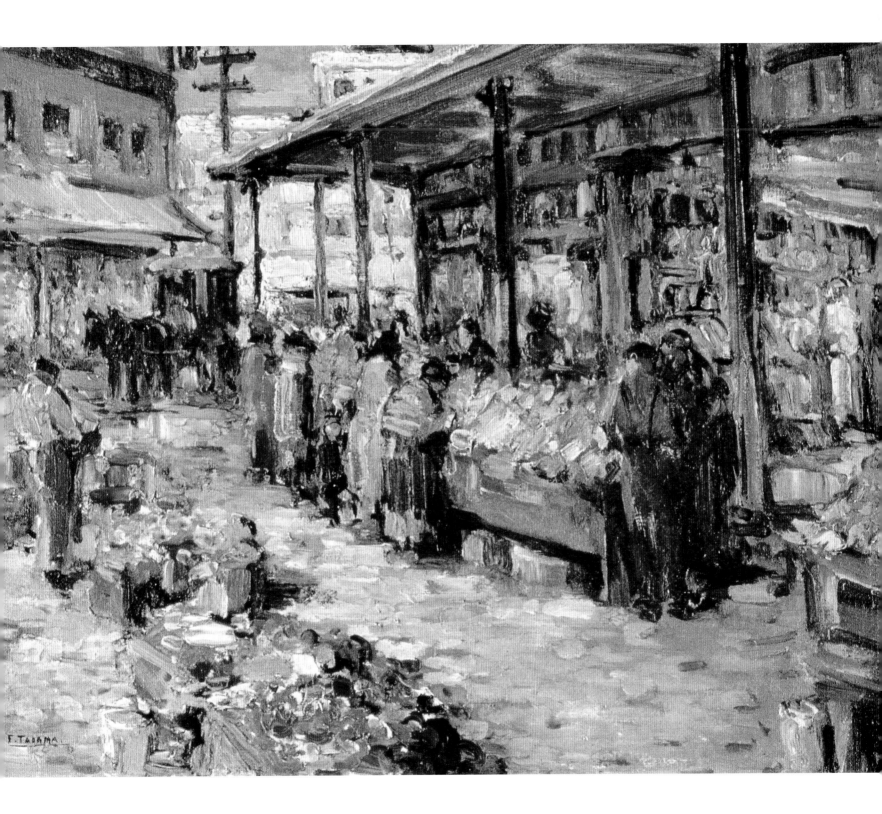

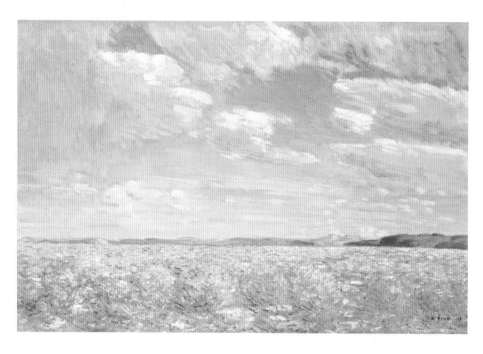

ABOVE:

CHILDE HASSAM

Afternoon Sky, Harney Desert | *1908*

oil on canvas, 20⅛ × 30⅛"
Portland Art Museum (08.1)
Gift of August Berg, Henrietta E. Failing, Winslow B. Ayer,
William D. Wheelwright, I.N. Fleischner, Estate of D.D. Thompson

LEFT:

CHARLES C. MCKIM

*Untitled (Looking south across the Columbia River toward
Multnomah Falls)* | *c. 1911*

oil on canvas, 14 × 18"
The Miranda Collection. Courtesy of The Sovereign Collection Gallery,
Portland

RIGHT:

LIONEL SALMON

Tatoosh Range | *c. 1919*

oil on board, 8¼ × 10¼"
Collection of Robert Lundberg

RIGHT:

W. P. WESTON

Scrub Pines, Howe Sound, West Coast | *c. 1930*

oil on canvas, 35 × 36"
Private collection. Courtesy of Heffel Fine Art Auction
House, Vancouver, B.C.

BELOW:

LAWREN HARRIS

Mount Robson | *c. 1929*

oil on canvas, 50½ × 60"
McMichael Canadian Art Collection, Kleinburg, Ontario
(Purchase 1979.20)

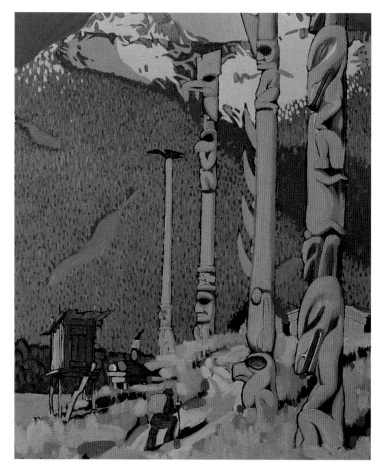

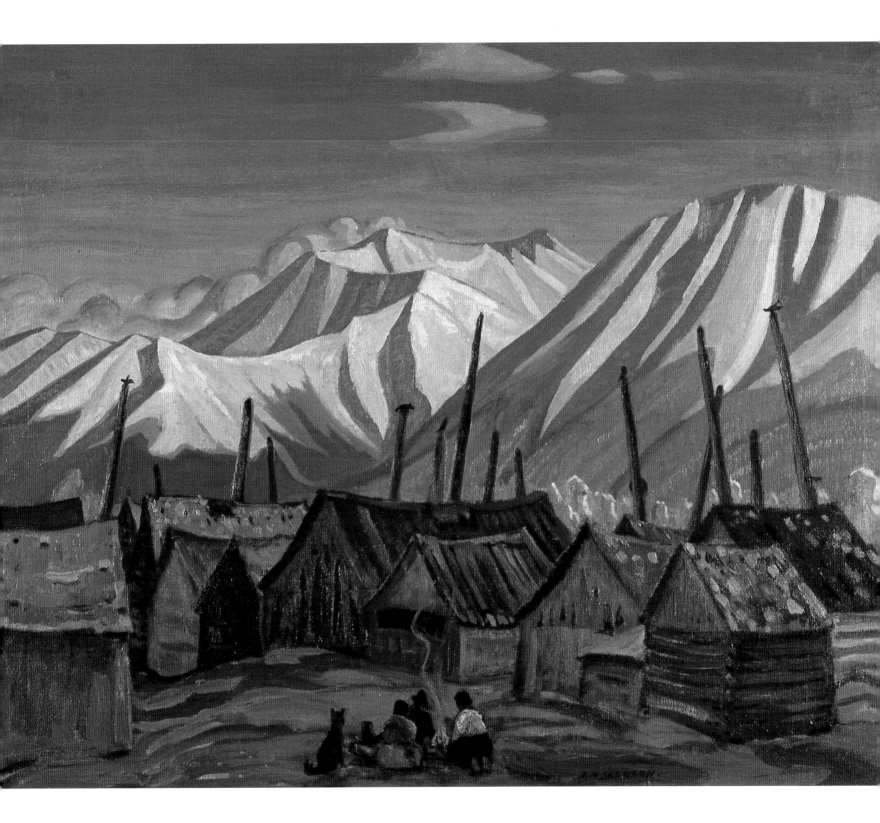

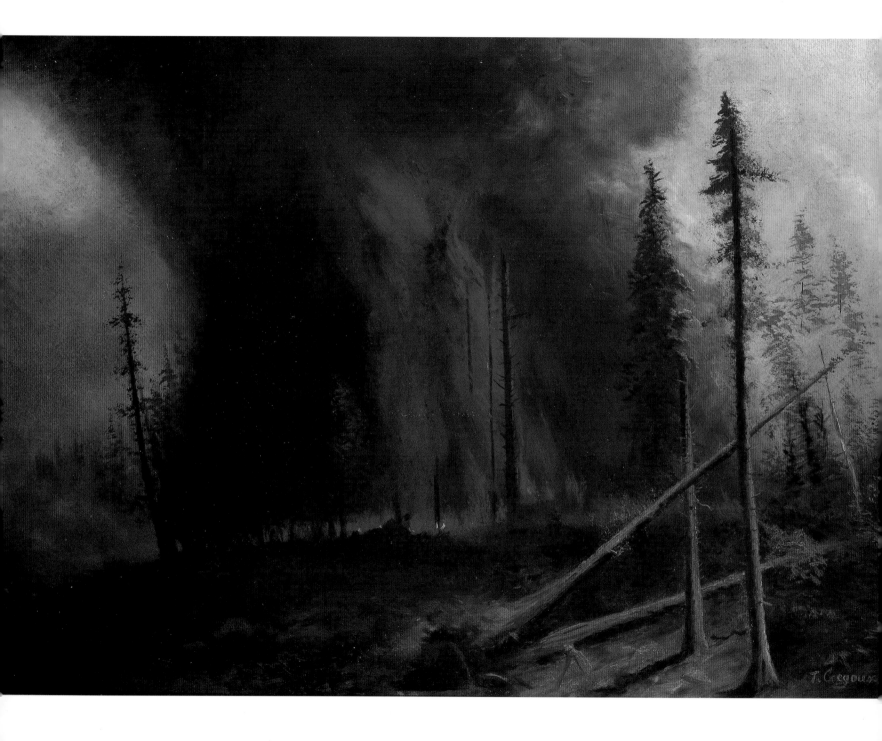

LEFT:
THÉODORE GÉGOUX
Forest Fire | 1925
oil on board, 21½ × 29½"
Collection of Michael Parsons

BELOW:
CHARLES HEPBURN SCOTT
The Black Tusk | 1927
oil and pencil on panel, 11½ × 14⅝"
Vancouver Art Gallery, Acquisition Fund (VAG 91.30)
Photo: Trevor Mills

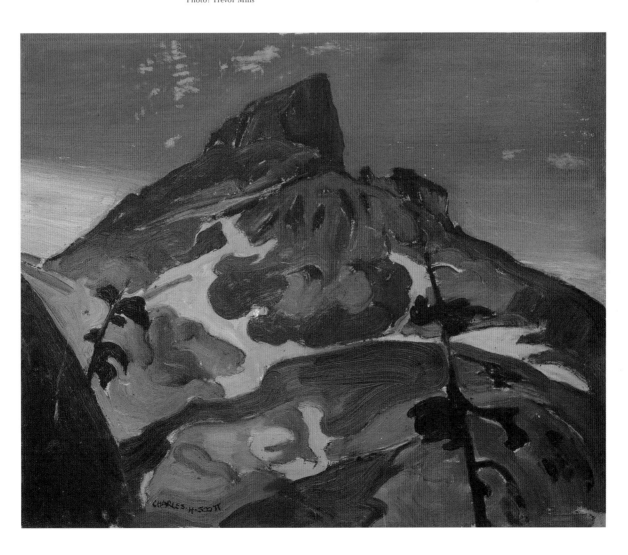

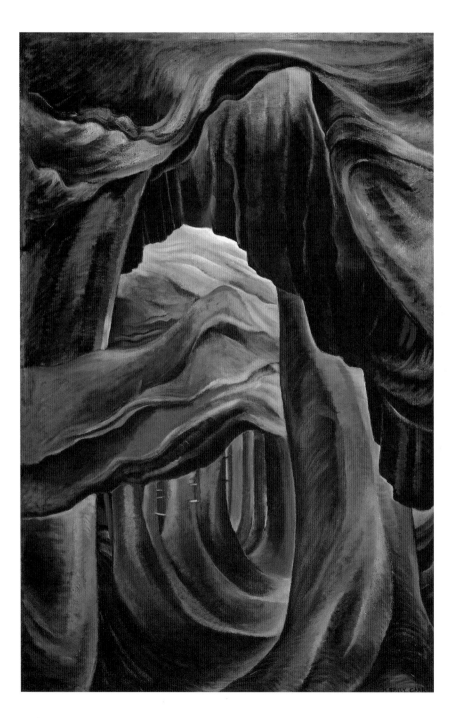

EMILY CARR
Forest, B.C. | *1931–32*
oil on canvas, 51⅛ × 34¼"
Vancouver Art Gallery, Emily Carr Trust (VAG 42.3.9)
Photo: Trevor Mills

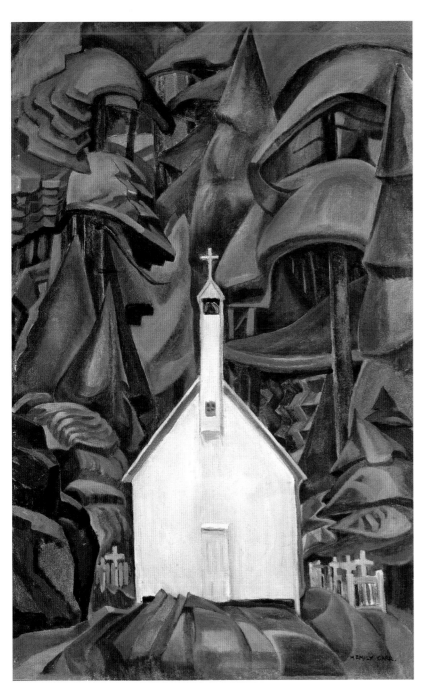

EMILY CARR
Indian Church | 1929
oil on canvas, 42¾ × 39"
Art Gallery of Ontario, Toronto. Bequest of Charles S.
Band, Toronto, 1970

RIGHT:

ELIZABETH WARHANIK
Mt. Shuksan | *c. 1930*
oil on canvas, 18 × 24"
Private collection. Courtesy of Martin-Zambito Fine Art, Seattle

BELOW:

FRANK TENNEY JOHNSON
Mt. Shuksan Moonlight | *1934*
oil on canvas, 25 × 30"
Collection of the Pigott family. Courtesy of Braarud Fine Art, La Conner, Washington

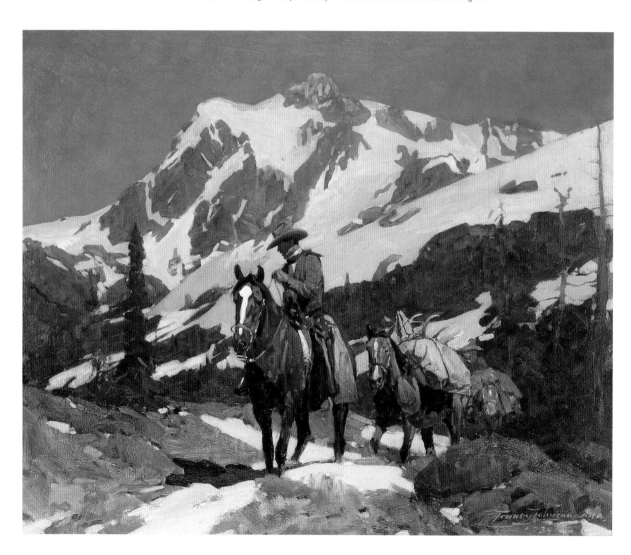

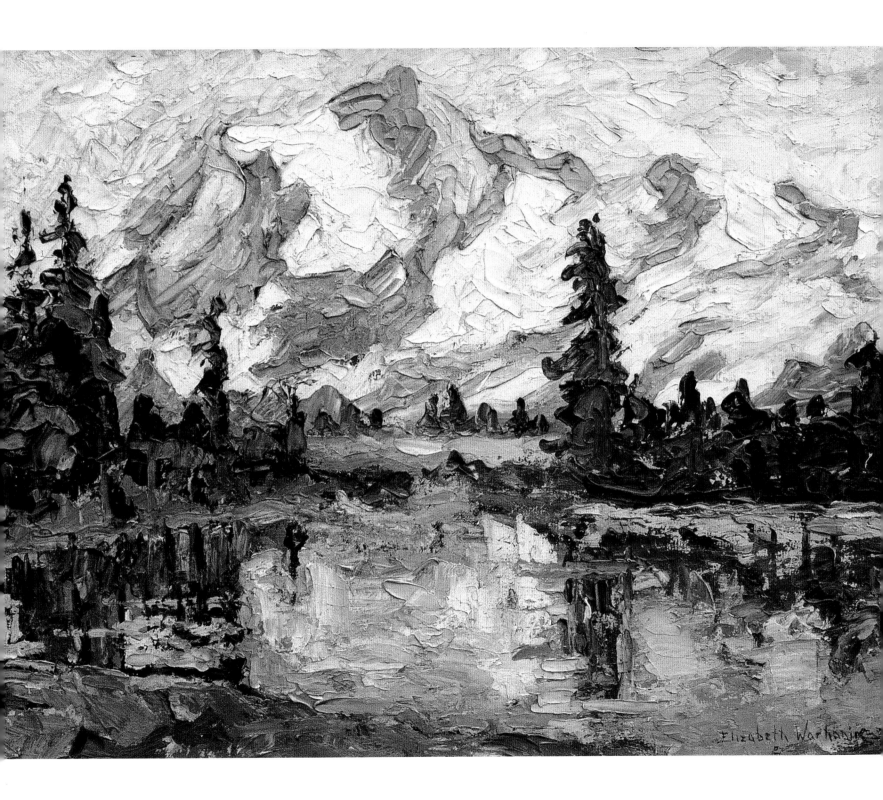

Elizabeth Wartonic

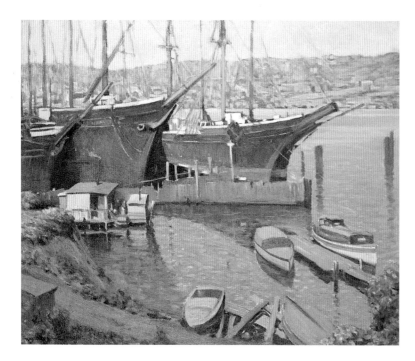

LEFT:

ROBERT ALEXANDER GRAHAM

Boats on Lake Union | *1931*

oil on canvas, 30 × 36"
Private collection. Courtesy of Braarud Fine Art, La Conner, Washington

RIGHT:

CLYDE LEON KELLER

Untitled (Portland waterfront) | *c. 1930*

oil on rough Masonite, 24 × 30"
Private collection

BELOW:

EDGAR FORKNER

Fishing Boats, Seattle Waterfront | *1927*

oil on canvas, 32 × 36"
Private collection. Courtesy of Braarud Fine Art, La Conner, Washington

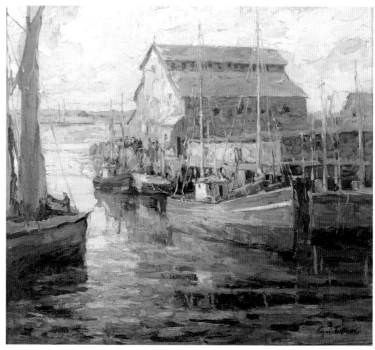

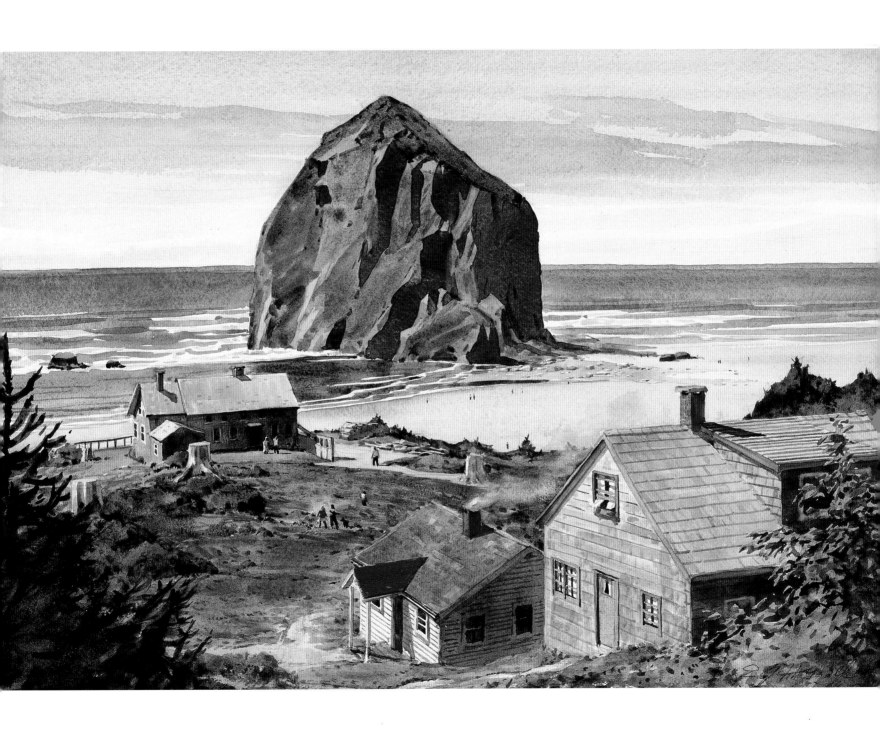

RIGHT:

KENNETH CALLAHAN
Logging Scene | *c. 1930s*
oil on canvas, 65 × 75"
Collection of the Rainier Club, Seattle
Photo: Richard Nicol

BELOW:

MORRIS GRAVES
Logged Mountains | *c. 1935–43*
oil on canvas, 26⅛ × 36⅛"
Smithsonian American Art Museum, Washington, D.C.

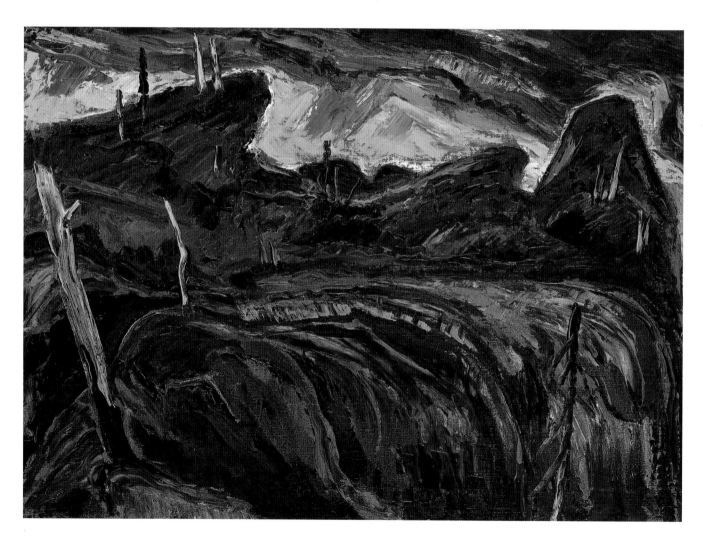

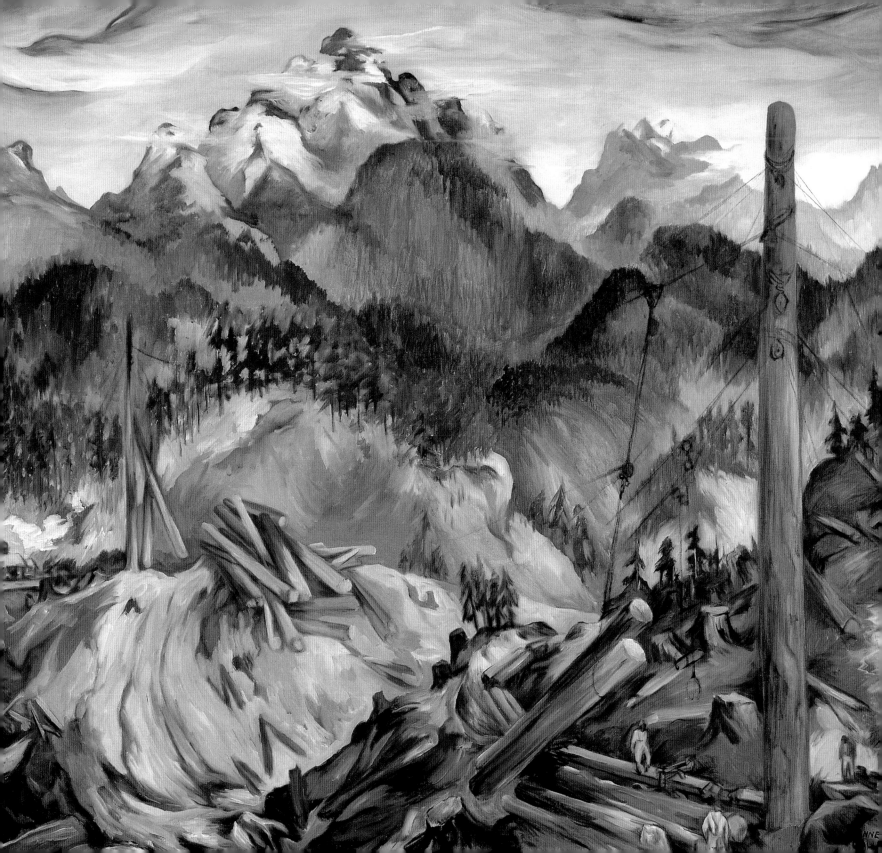

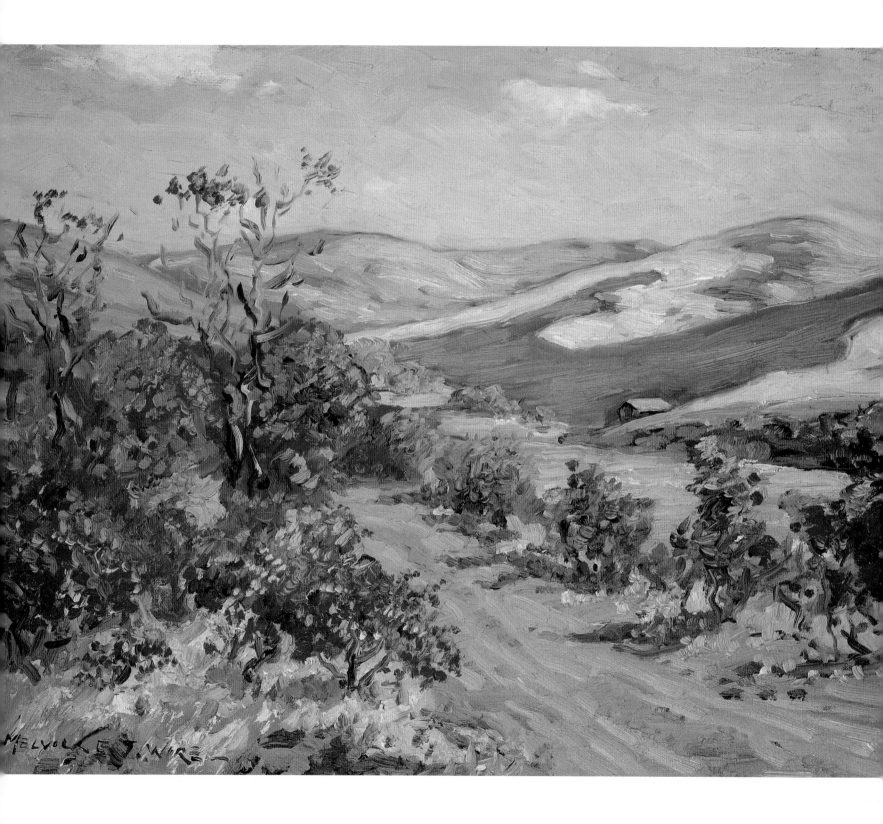

LEFT:

MELVILLE T. WIRE
Untitled (Desert ranch) | *c. 1930*
oil on canvas, 14 × 18"
Collection of Robert Lundberg

RIGHT:

MARGARET GOVE CAMFFERMAN
View from Old Homestead Ranch | *1936*
oil on canvas, 31 × 44⅛"
Seattle Art Museum, Eugene Fuller Memorial Collection
Photo: Paul Macapia

BELOW:

THAYNE LOGAN
Sheep's Rock | *1935*
watercolor, 9 × 13"
The Miranda Collection. Courtesy of The Sovereign Collection Gallery,
Portland

LEFT:

KAMEKICHI TOKITA
Street │ *c. 1930s*

oil on canvas, 24 × 18"
Collection of the artist's family. Courtesy of Wing Luke Asian
Museum, Seattle
Photo: Paul Macapia

BELOW:

ALBERT RUNQUIST
View of Multnomah Hotel, Portland │ *c. 1935*

oil on canvas, 29½ × 35"
Oregon Historical Society, Portland (102283)

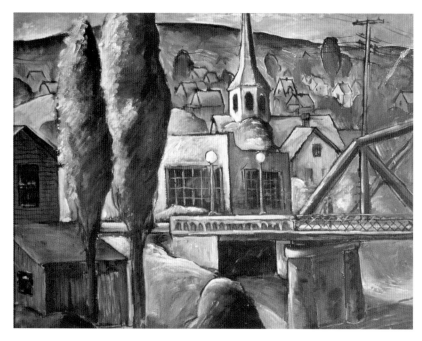

LEFT:

KENJIRO NOMURA
Renton Bridge | *1932*

oil on canvas, 24 × 31"
Collection of George and Betty Nomura. Courtesy of Wing
Luke Asian Museum, Seattle
Photo: Paul Macapia

RIGHT:

DOROTHY DOLPH JENSEN
My City | *c. 1932*

oil on canvas, 20 × 24"
Collection of Erando and Lucille Cacallori. Courtesy of
Martin-Zambito Fine Art, Seattle

BELOW:

DAVID MCCOSH
Iron Bridge | *c. 1941*

oil on canvas, 20 × 30⅛"
Portland Art Museum. Ayer Fund (41.14)

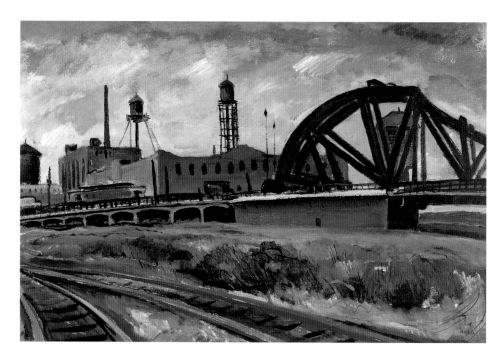

W. P. WESTON
Cheam | *1933*
oil on canvas, 42 × 48"
Hart House Permanent Collection, University of Toronto
Photo: Thomas Moore Photography

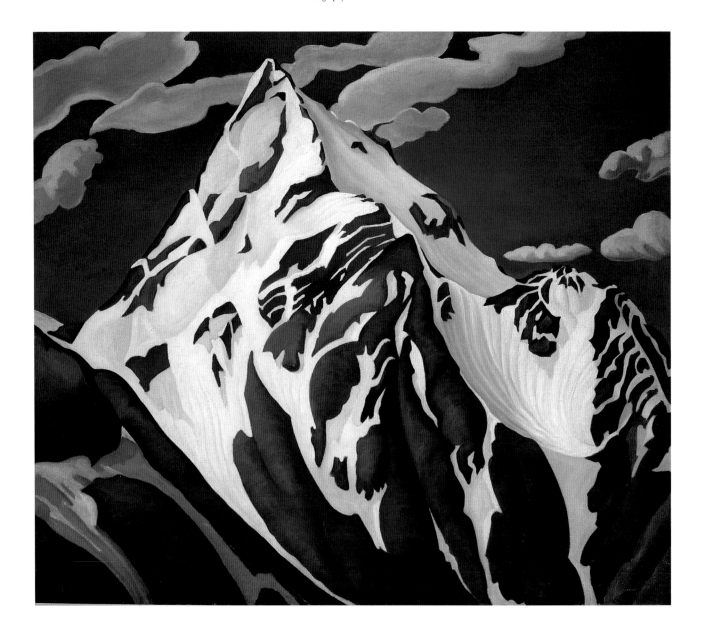

JOCK MACDONALD
Castle Towers—Garibaldi Park, B.C. | *1943*
oil on canvas, 28⅛ × 38⅛"
Vancouver Art Gallery, Acquisition Fund (VAG 90.36)
Photo: Holly Hames

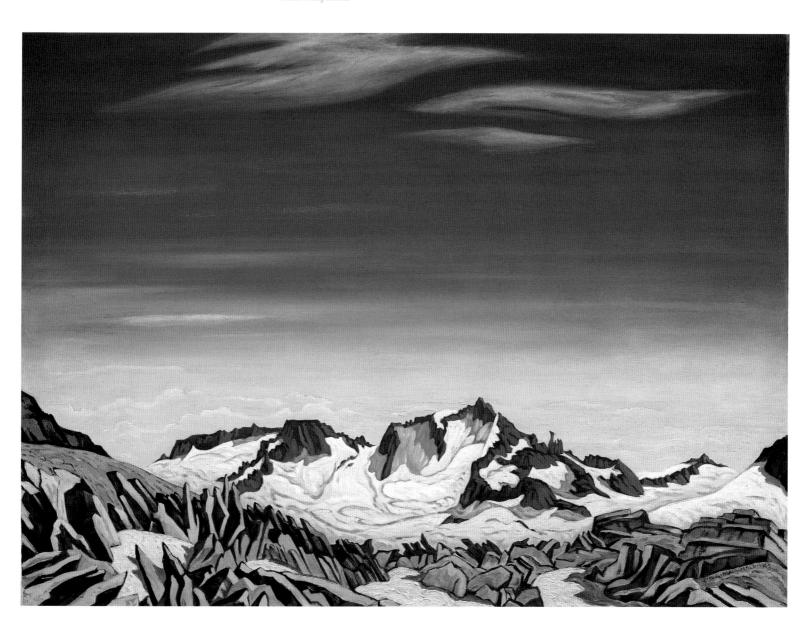

LEFT:

PETER CAMFFERMAN

The Deep Forest | *1936*

oil on board, 26½ × 30½"
Seattle Art Museum, Eugene Fuller Memorial Collection
Photo: Howard Giske

BELOW:

LANCE WOOD HART

Coast Valley (Willamette) | *1931*

watercolor, 11¾ × 18"
Collection of the Hallie Ford Museum of Art, Willamette University,
Salem, Oregon. Gift of Lucy Hart
Photo: Dale Peterson

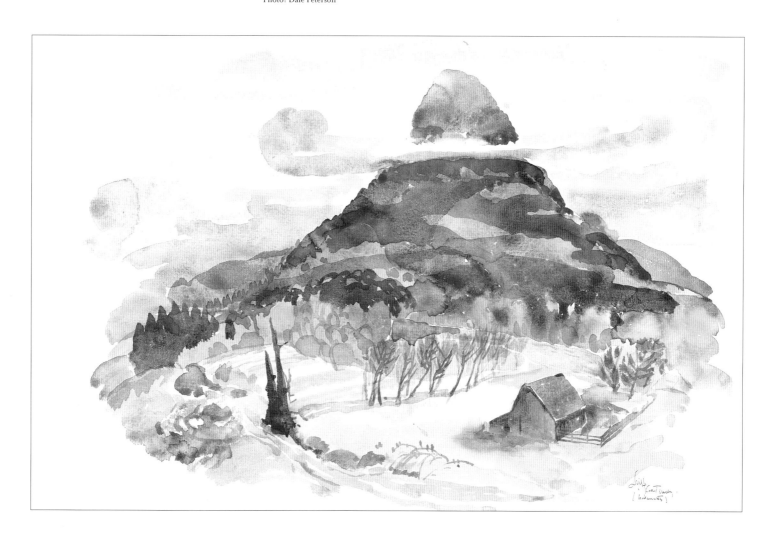

MALCOLM ROBERTS
View of Aurora Bridge | 1936
tempera, 17¾ × 22½"
Seattle Art Museum, Eugene Fuller Memorial Collection
Photo: Howard Giske

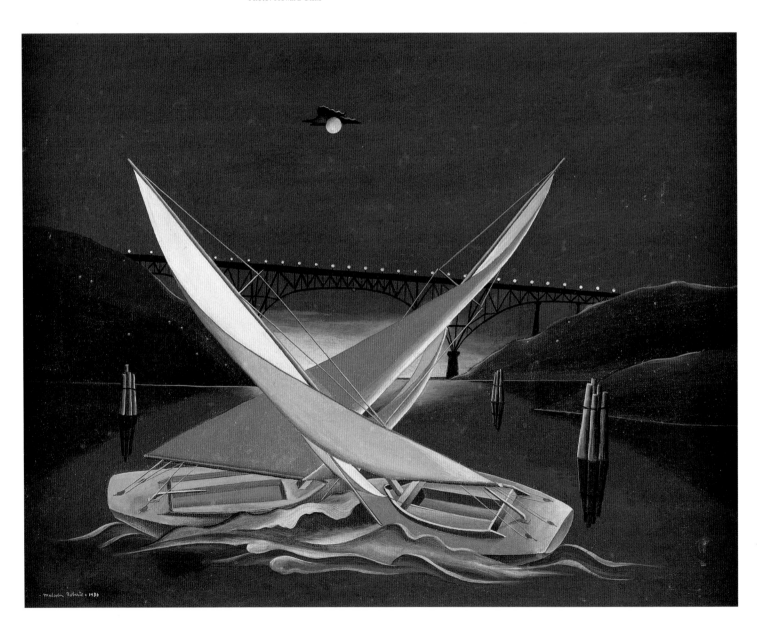

FRED H. VARLEY
Night Ferry, Vancouver | *1937*
oil on canvas, 32¼ × 40¼"
McMichael Canadian Art Collection, Kleinburg, Ontario (Purchase 1983.10)

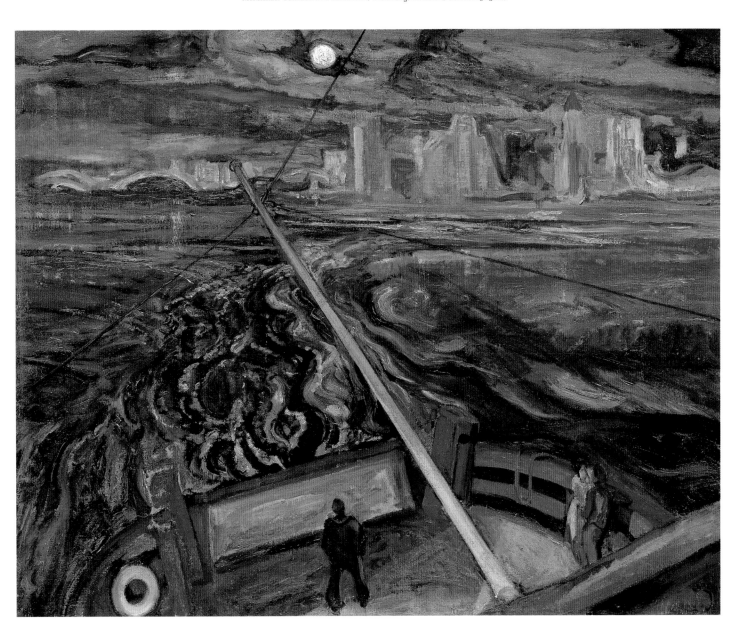

LEFT:

JANE BALDWIN
Palouse Farm | *c. 1938*
gouache, 14 × 18¾"
Private collection. Courtesy of Martin-Zambito Fine Art, Seattle

BELOW:

MARTINA GANGLE
Untitled (Strawberry pickers) | *c. 1938*
oil on canvas, 18½ × 43½"
Collection of Michael Parsons

RIGHT:

C. S. PRICE
Winter | *1940*
oil on canvas, 32 × 38"
Portland Art Museum. Lent by Public Buildings Service, General Services Administration
(L42.39)

BELOW:

CHARLES HEANEY
The Mountains | *1938*
oil on canvas, 34½ × 42¼"
Portland Art Museum. Lent by Public Buildings Service, General Services Administration
(L45.3.4)

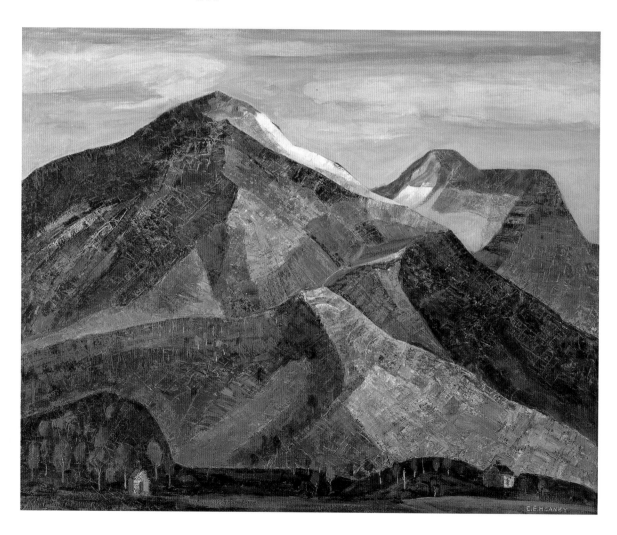

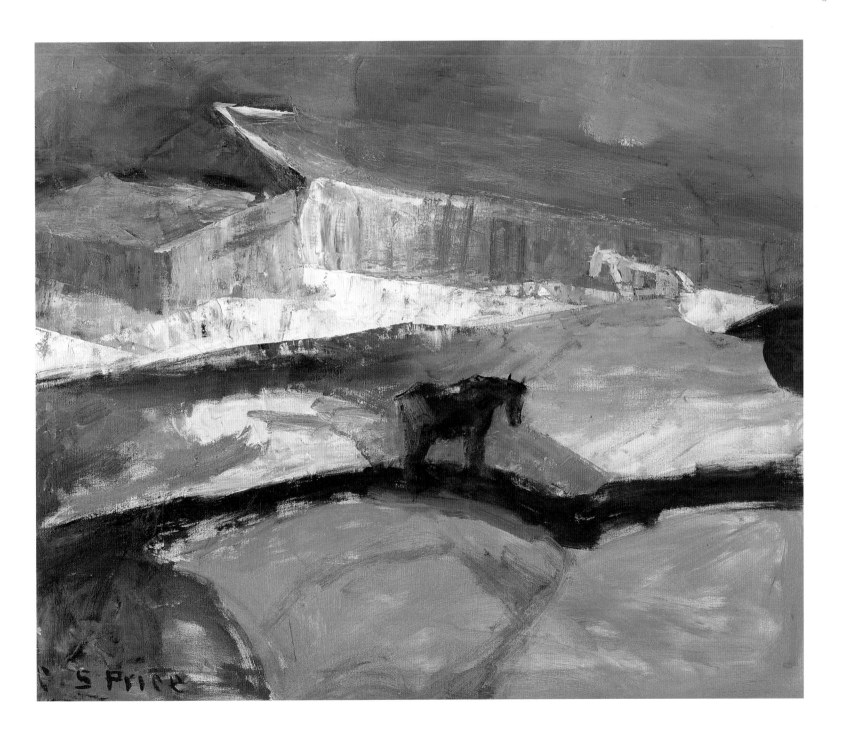

BLANCHE MORGAN LOSEY
Bombardier's View | *c. 1942*
watercolor, 23 × 17¾"
Private collection. Courtesy of
Martin-Zambito Fine Art, Seattle

CARL HALL
Earth, That Is Sufficient (Willamette Valley) | *1950*
oil on canvas, 29½ × 41¾"
Collection of the Hallie Ford Museum of Art, Willamette University,
Salem, Oregon. Purchased on the occasion of Professor Hall's
retirement from the faculty in 1986, Maribeth Collins Art Fund.
By permission of Phyllis Hall
Photo: Dale Peterson

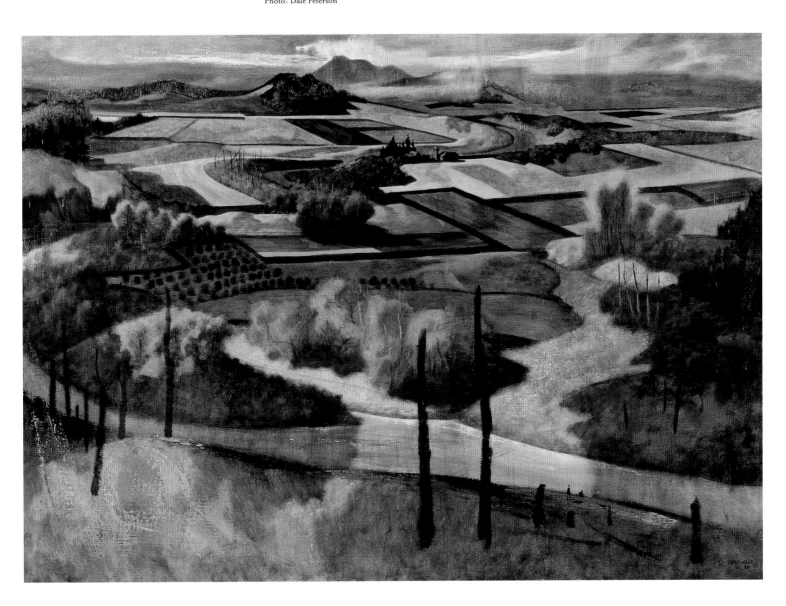

RIGHT:

SYDNEY LAURENCE
Aurora Bridge | *1934*
oil on canvas laid down on Masonite, 12 × 16"
Private collection. Courtesy of Braarud Fine Art, La Conner, Washington

BELOW:

AMBROSE PATTERSON
Portage Bay | *1954*
oil on canvas, 31 × 44⅛"
Seattle Art Museum, Eugene Fuller Memorial Collection
Photo: Paul Macapia

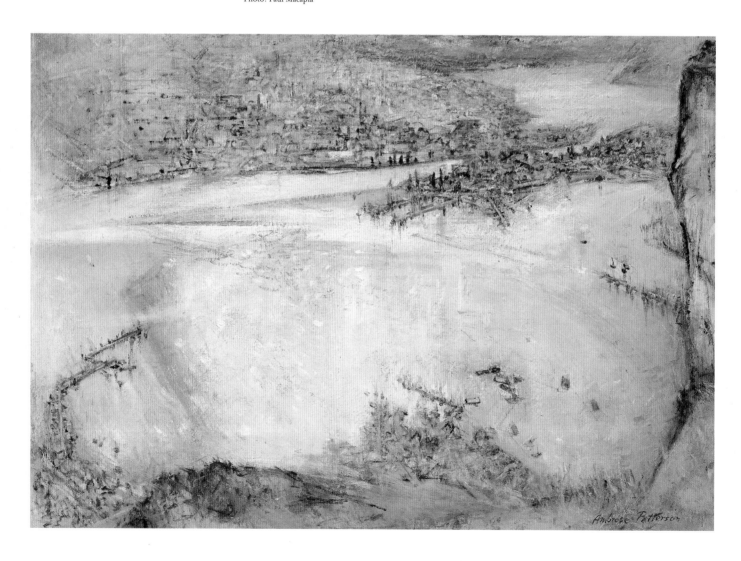

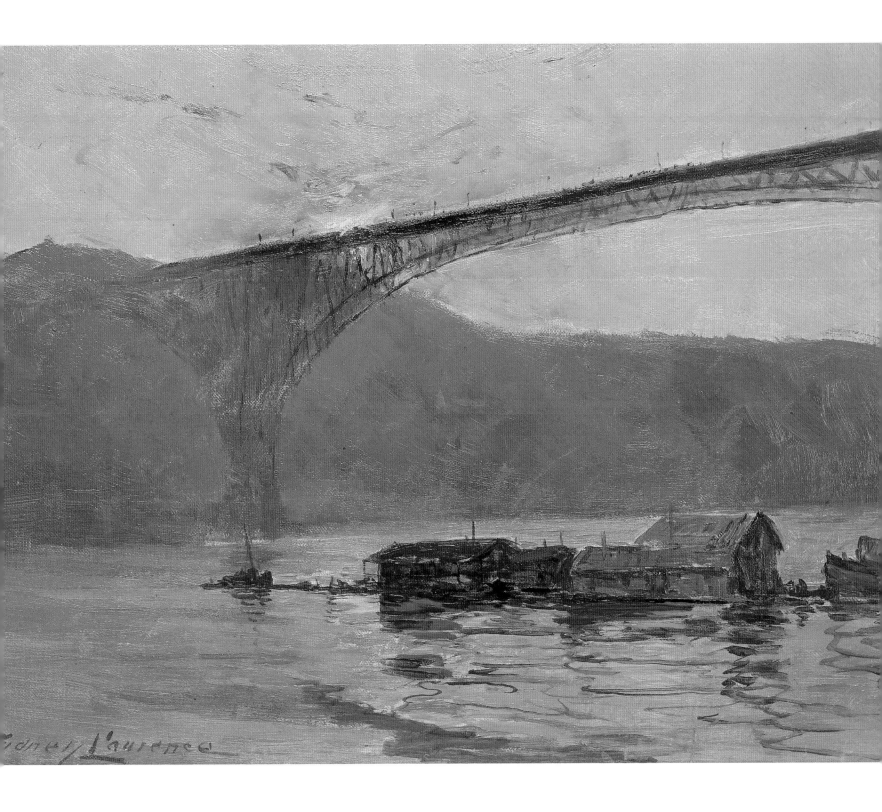
Sidney Laurence

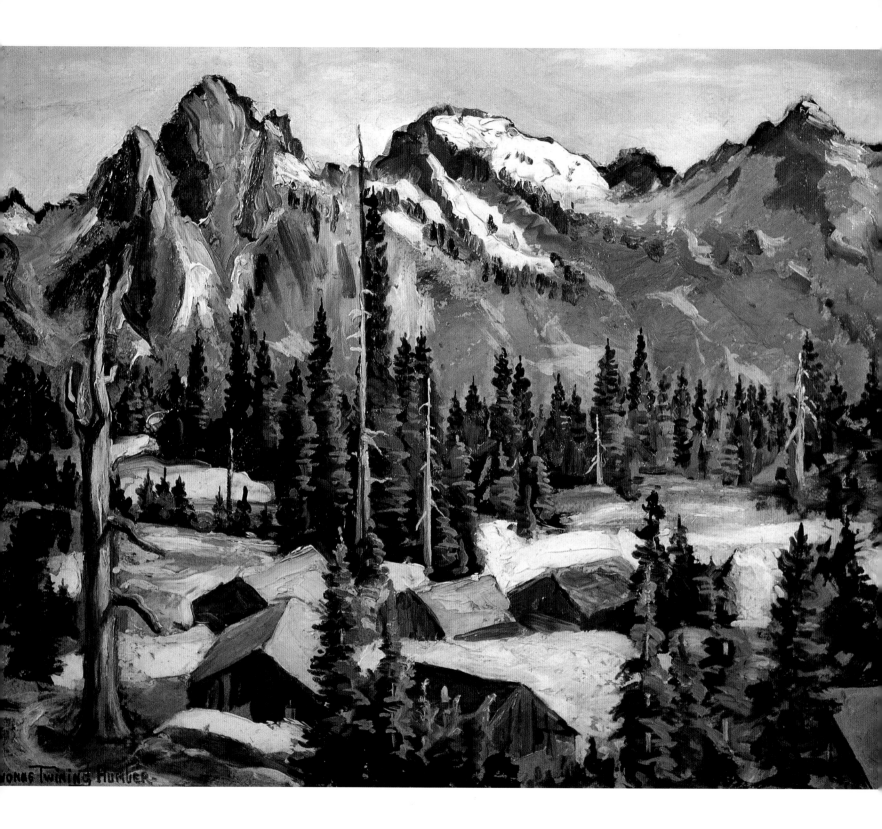

Yvonne Twining Humber

LEFT:

YVONNE TWINING HUMBER
Tatoosh Range | *c. 1944*
oil on board, 16 × 20"
Courtesy of Martin-Zambito Fine Art, Seattle

BELOW:

EUSTACE PAUL ZIEGLER
Mt. Rainier—Fording the Nisqually River | *c. 1940*
oil on board, 16 × 20"
Private collection. Courtesy of Braarud Fine Art, La Conner, Washington

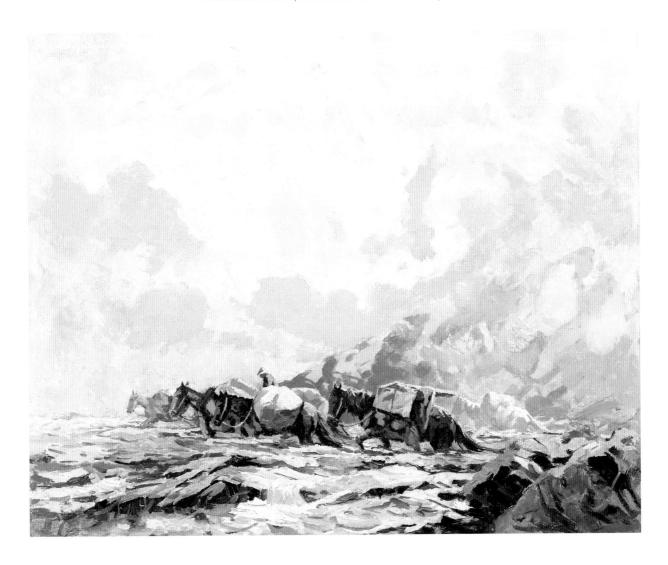

RIGHT:

JACK MCLARTY
The Gas Station | *1942-43*
oil on canvas, 24½ × 32½"
Collection of Michael Parsons

BELOW:

RUDOLPH ZALLINGER
Northwest Salmon Fishermen | *1941*
egg tempera on panel, 25¾ × 35⅝"
Seattle Art Museum, Eugene Fuller Memorial Collection
Photo: Howard Giske

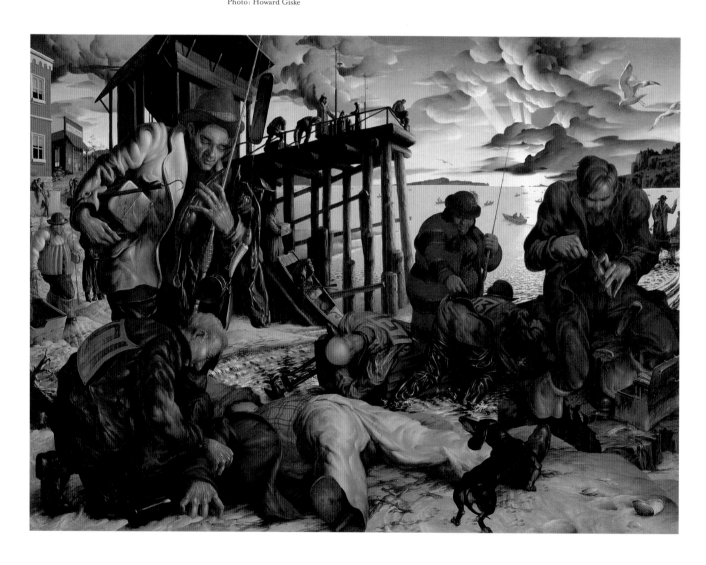

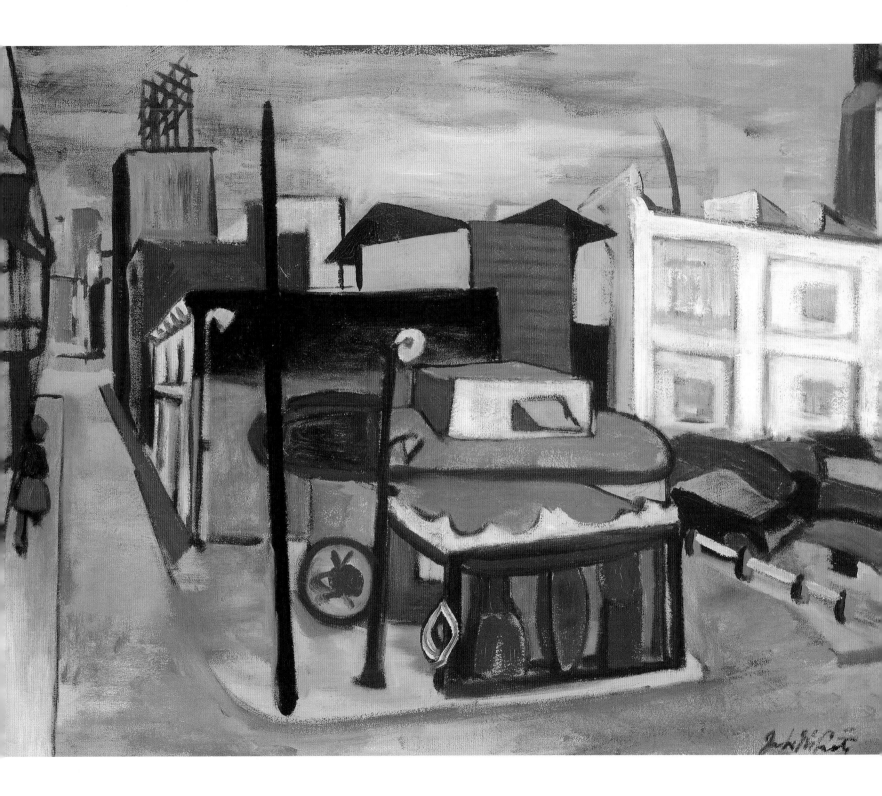

RIGHT:

DONALD W. PEEL
Landscape | *c. 1950*
oil on Masonite, 24 × 28"
Courtesy of Martin-Zambito Fine Art, Seattle

BELOW:

VANESSA HELDER
Coulee Dam—Looking West | *c. 1940*
watercolor, 18 × 21⅞"
Northwest Museum of Arts & Culture/Eastern Washington State Historical Society,
Spokane, Washington

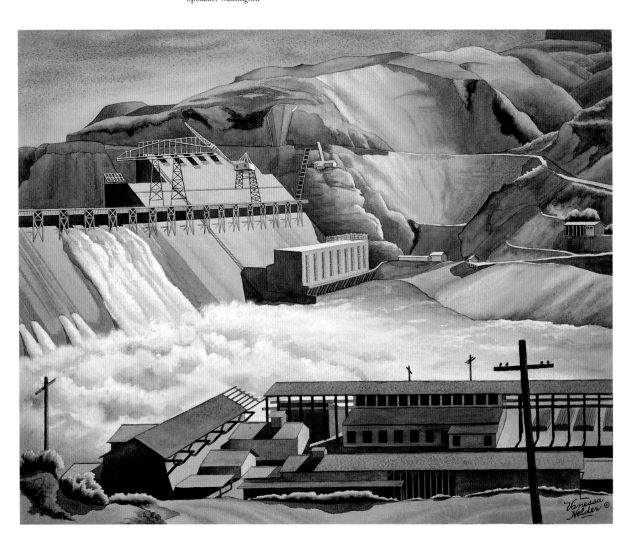

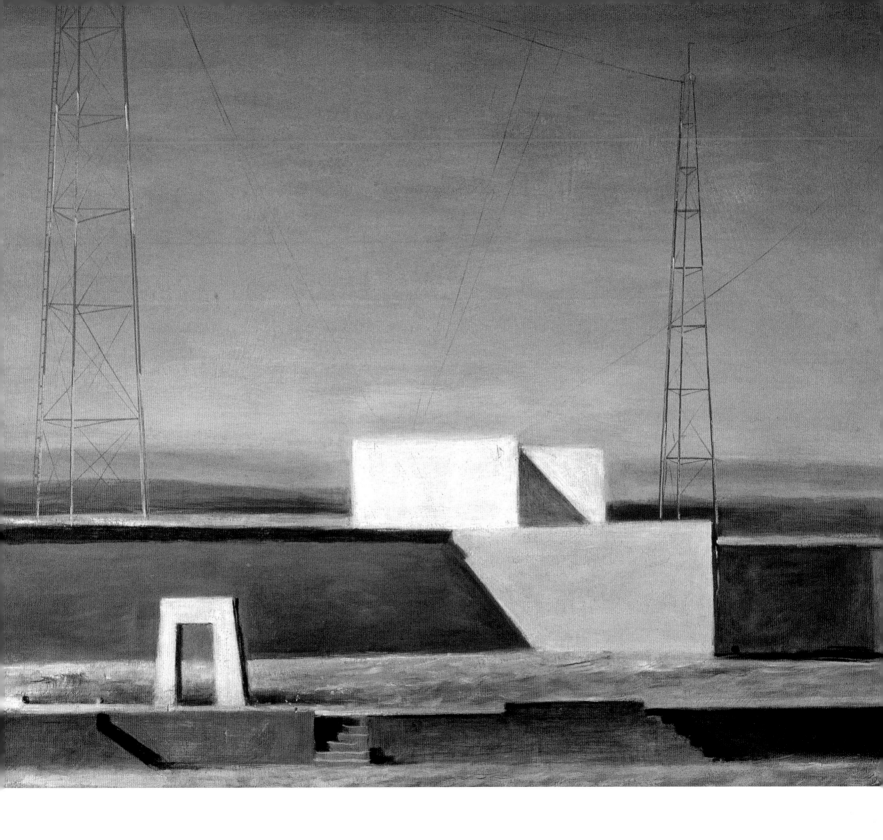

RIGHT:

JEFFERSON TESTER
Crater Lake | *1967*
oil on canvas, 23½ × 29½"
Collection of Wallace Huntington

BELOW:

PERCY MANSER
Dawn Patrol | *c. 1950*
oil on canvas, 30¾ × 37"
Collection of Michael Parsons

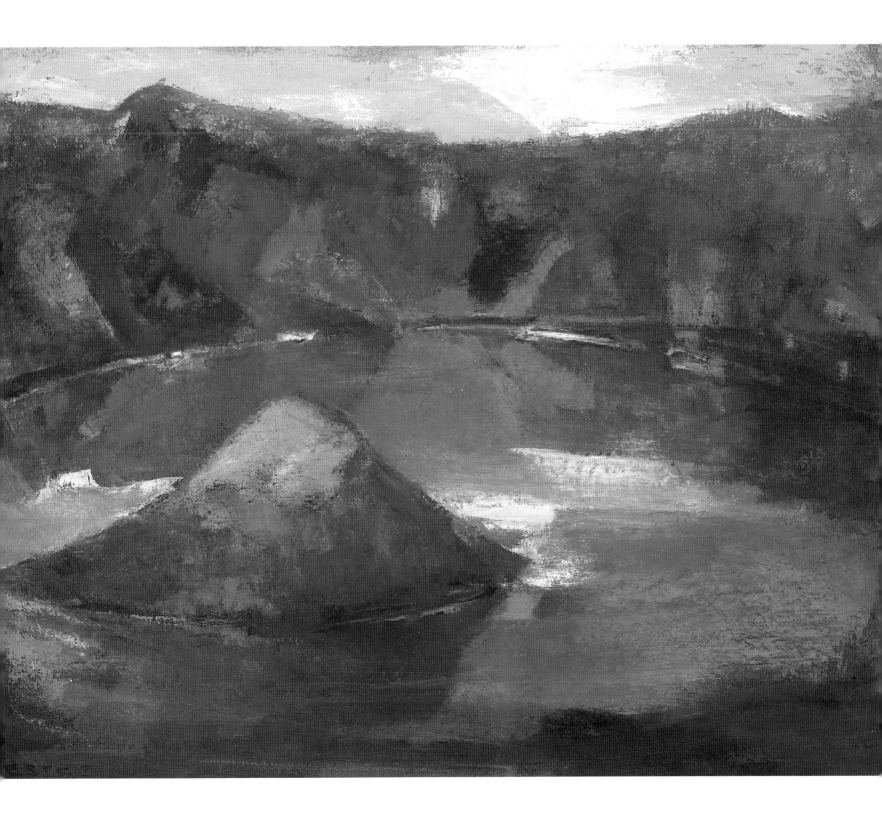

RIGHT:

ARTHUR RUNQUIST
Untitled (Clearcut on Neahkahnie Mountain) | *c. 1950*
oil on Masonite, 16 × 20"
Collection of Michael Parsons

BELOW:

JACK SHADBOLT
Indian Village | *1948*
oil on paperboard, 30 × 40"
Vancouver Art Gallery. Gift of the Estate of Dr. Velen Fanderlik, Trail, B.C. (VAG 86.22)
Photo: Teresa Healy

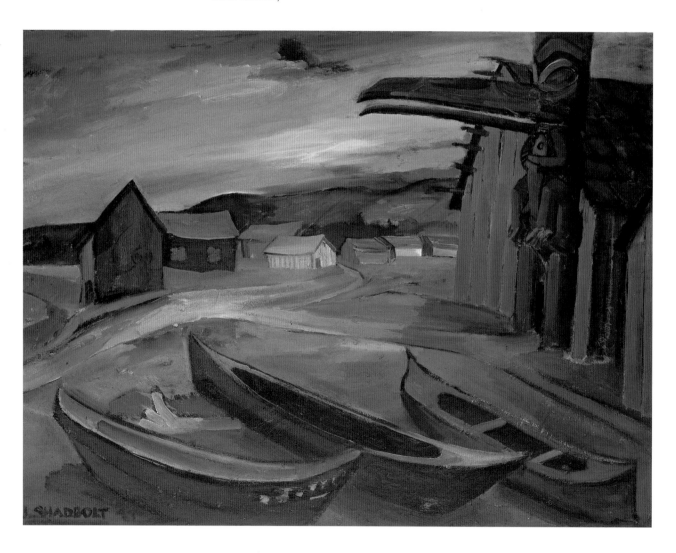

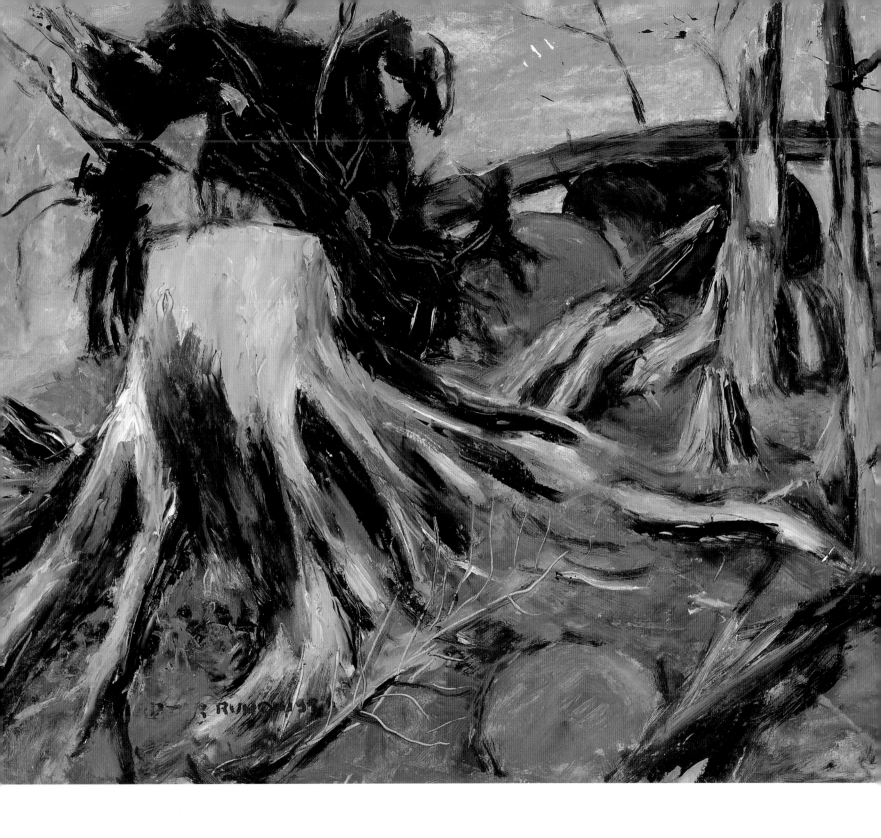

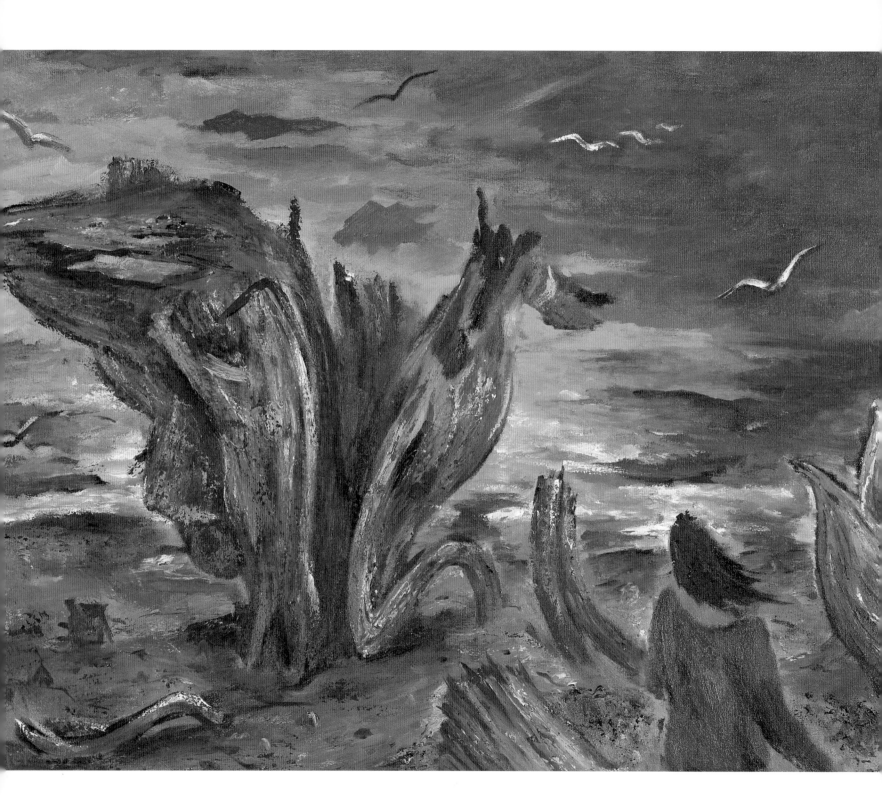

LEFT:

WILLIAM GIVLER
Driftage | *1949*
oil on canvas, 25½ × 35½"
Collection of the Hallie Ford Museum of Art, Willamette University, Salem, Oregon.
Maribeth Collins Art Fund/Gift of Elaine Bernat and Roger Saydack
Photo: Dale Peterson

BELOW:

CHARLES VOORHIES
Grizzly Mountain | *c. 1948*
oil on canvas, 22½ × 27"
Collection of Michael Parsons

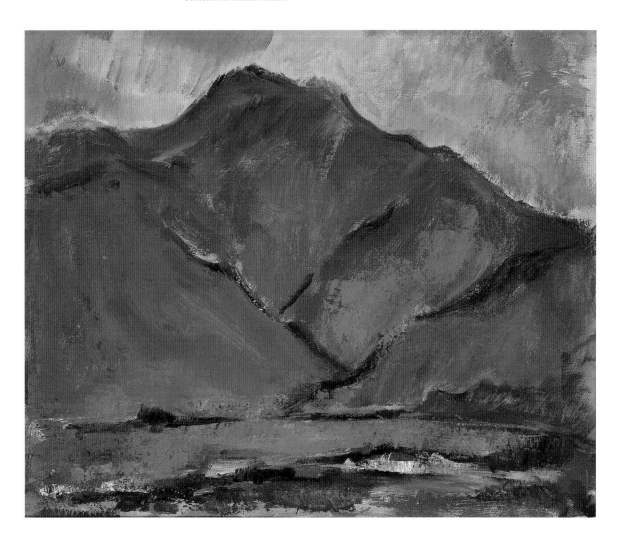

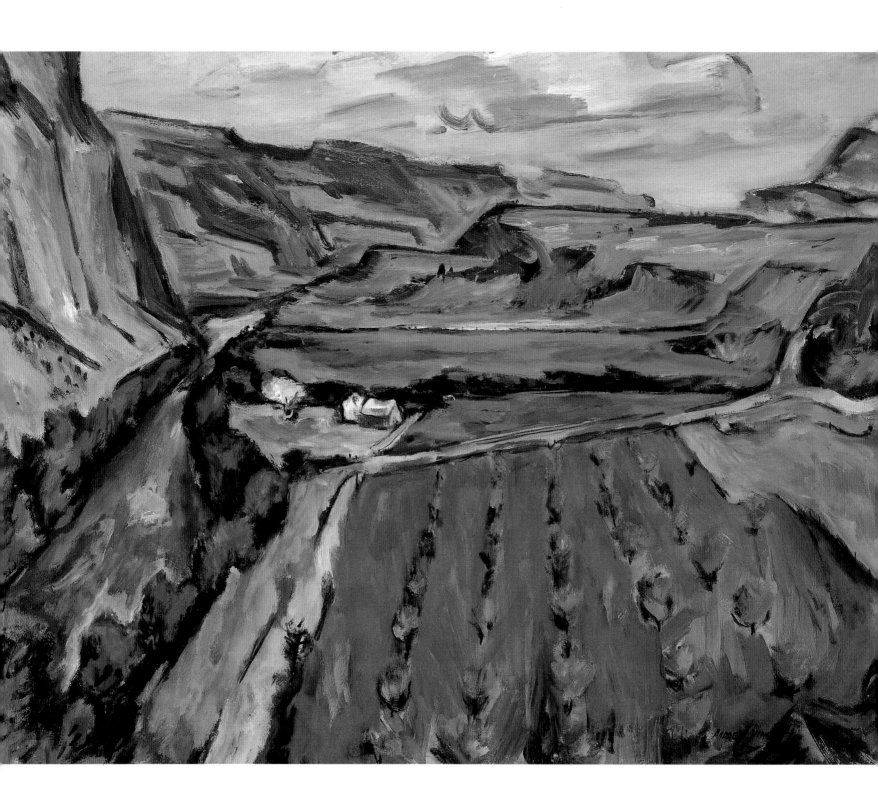

LEFT:

ANDREW VINCENT
The Boegli Ranch (Crooked River at Cove Palisades) | *c. 1960*
oil on canvas, 25½ × 33"
Collection of Michael Parsons

BELOW:

WALTER F. ISAACS
Lake Chelan | *1947*
oil on canvas, 21¾ × 31¼"
Seattle Art Museum, Eugene Fuller Memorial Collection
Photo: Howard Giske

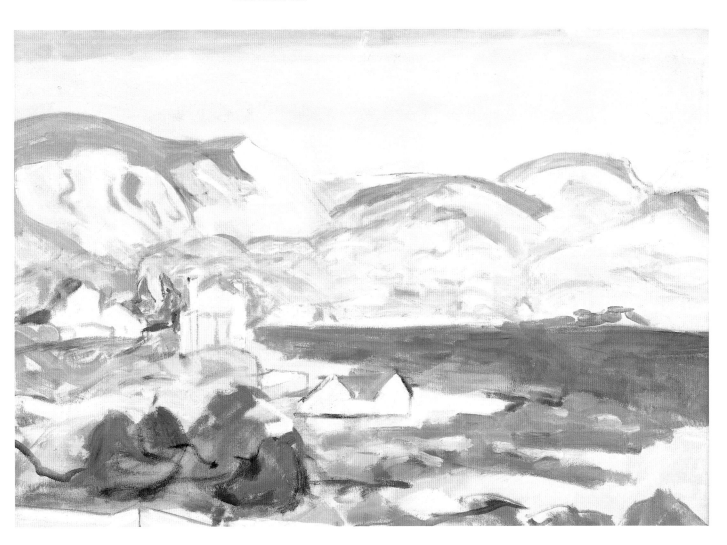

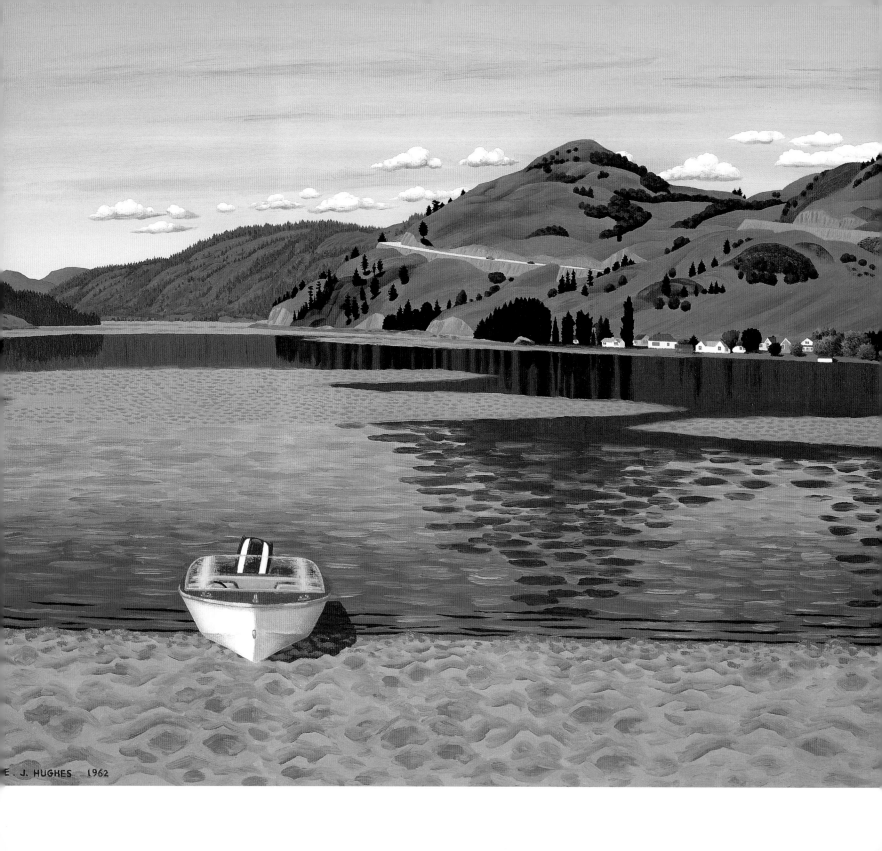

E. J. HUGHES 1962

LEFT:

E. J. HUGHES
The Beach at Kalamalka Lake | 1962
oil on canvas, 25 × 32"
Private collection. Courtesy of Heffel Fine Art Auction House, Vancouver, B.C.

BELOW:

MAXWELL BATES
Beautiful B.C. | 1966
oil on canvas, 35⅞ × 48"
Vancouver Art Gallery, Siwash Auction Funds (VAG 68.15)
Photo: Teresa Healy

RIGHT:
WILLIAM SLATER
Dark Spring | *c. 1988*
oil on canvas, 60 × 84"
Private collection

BELOW:
GUY ANDERSON
Storm through the Channel | *1958*
tempera, watercolor, crayon, and ink on paper, 7½ × 22⅛"
Seattle Art Museum, Eugene Fuller Memorial Collection
Photo: Chris Eden

RIGHT:

RICHARD GILKEY
Skagit Valley Landscape | *1974*
oil on canvas, 48 × 68"
Private collection. Courtesy of Janet Huston Gallery, La Conner, Washington

BELOW:

WESLEY WEHR
Camano | *1963*
crayon on paper, 5⅜ × 5¾"
Northwest Museum of Arts & Culture/Eastern Washington State Historical Society,
Spokane, Washington.
Gift of Dr. and Mrs. Ulrich Fritzsche

LEFT:

FAY CHONG
Lake Union Landscape | 1955
watercolor and Chinese ink on paper, 21¾ × 15⅜"
Collection of SAFECO, Seattle
Photo: Bill Bachhuber

BELOW:

GEORGE TSUTAKAWA
Winter Lake Ketchelis | 1970
sumi with gansai, 9½ × 28"
Collection of the artist's family
Photo: Paul Macapia

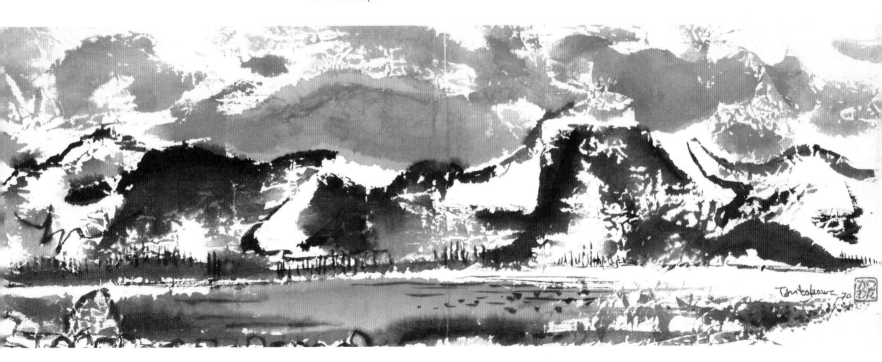

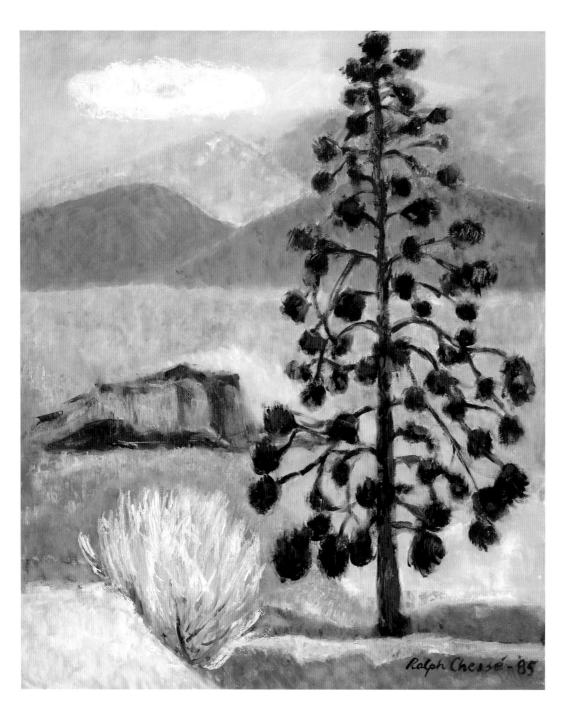

LEFT:

RALPH CHESSÉ
Jefferson Pine | *c. 1985*
oil on canvas, 34 × 28"
Private collection

RIGHT:

RICHARD MORHOUS
Meander | *1987*
acrylic on paper, 24 × 32½"
Courtesy of Lisa Harris Gallery, Seattle

LEFT:

GORDON SMITH
Shannon Falls | *1991*
acrylic on canvas, 80 × 60"
Collection of Nesbitt Burns Ltd., Vancouver, B.C.
Photo: Trevor Mills, Vancouver Art Gallery

RIGHT:

NEIL MEITZLER
Blue Light | *1998*
oil on canvas, 59 × 46½"
Courtesy of Martin-Zambito Fine Art, Seattle

RIGHT:

WILLIAM ELSTON
Kingdome | *1989*
oil on canvas, 48 × 60"
Collection of University of Washington Medical Center, Seattle

BELOW:

TAKAO TANABE
Queen Charlotte Islands | *1995*
acrylic on canvas, 32 × 72"
Courtesy of Equinox Gallery, Vancouver, B.C.

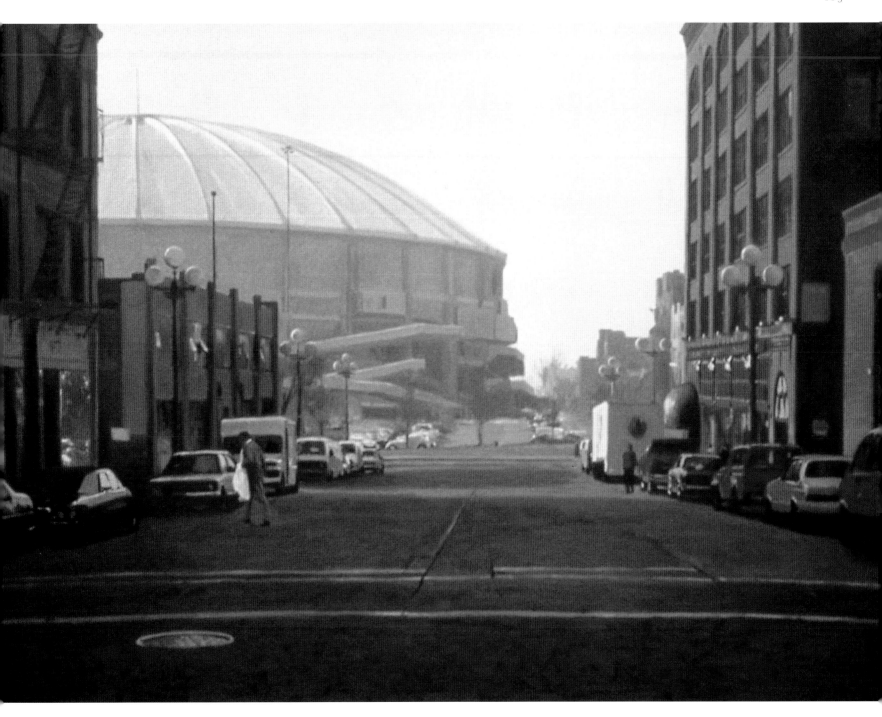

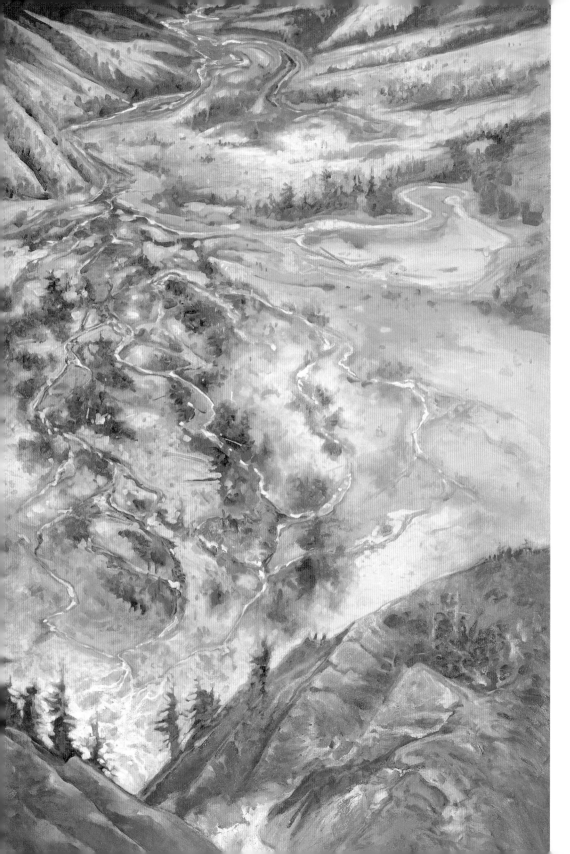

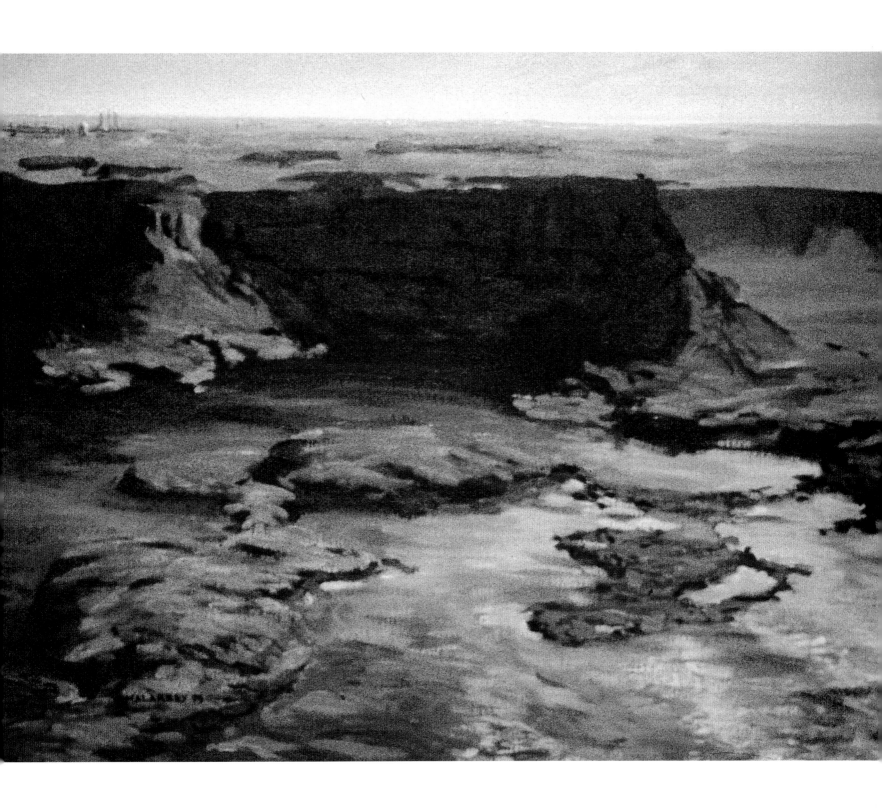

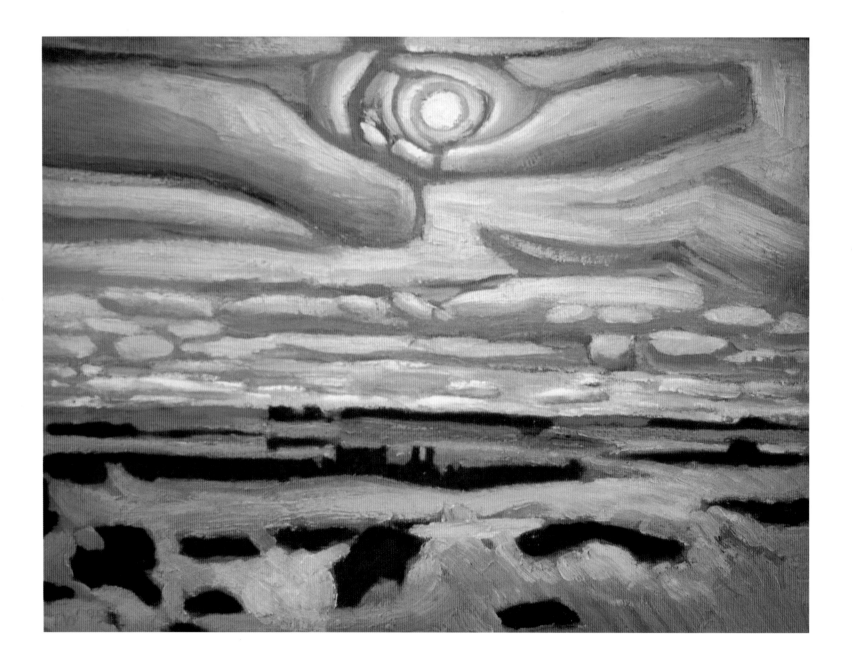

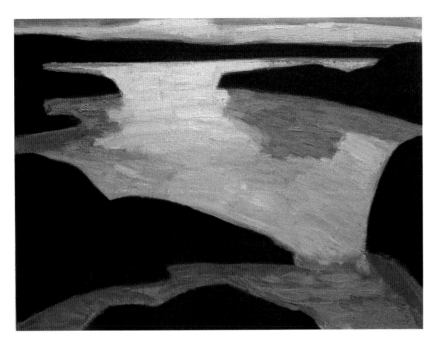

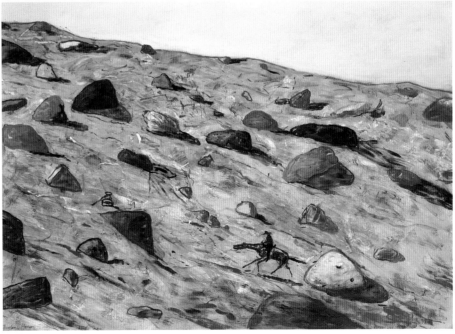

ABOVE:

JOHN COLE
Bay of Mystery | *1997*
oil on linen, 36 × 48"
Collection of Rosalyn Solomon and David Groff.
Courtesy of Lisa Harris Gallery, Seattle

LEFT:

THOMAS WOOD
Near Soap Lake | *1995*
oil on board, 12 × 16"
Private collection. Courtesy of Lisa Harris Gallery, Seattle

RIGHT:

GAYLEN HANSEN
Rocky Slope | *1990*
oil on canvas, 60 × 84"
Courtesy of Linda Hodges Gallery, Seattle

FAR RIGHT:

JULIANA HEYNE
View from Steptoe Butte #6 | *1990*
oil stick on paper, 47 × 70"
Courtesy of the artist and Francine Seders Gallery, Seattle

RIGHT:

SUSAN BENNERSTROM
Obstacles | *1997*
pastel on paper, 26 ½ × 36⅜"
Private collection. Courtesy of Davidson Galleries, Seattle

BELOW:

SUSAN BENNERSTROM
Seam | *1995*
pastel on paper, 26 ½ × 30½"
Private collection. Courtesy of Davidson Galleries, Seattle

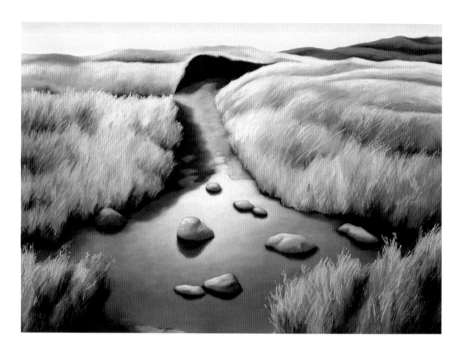

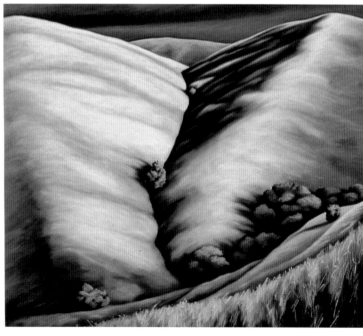

RIGHT:

BARRY PELZNER
1999/12 (Shining slough) | *1999*
conte crayon on museum board, 5 × 8"
Collection of Gail and Steve Ossowski.
Courtesy of the artist and Froelick Gallery, Portland

BELOW:

SALLY CLEVELAND
The Arco Juneau, the Tidewater, and the Agility on the Willamette River | *1999*
oil on panel, 11 × 15½"
Private collection. Courtesy of Augen Gallery, Portland

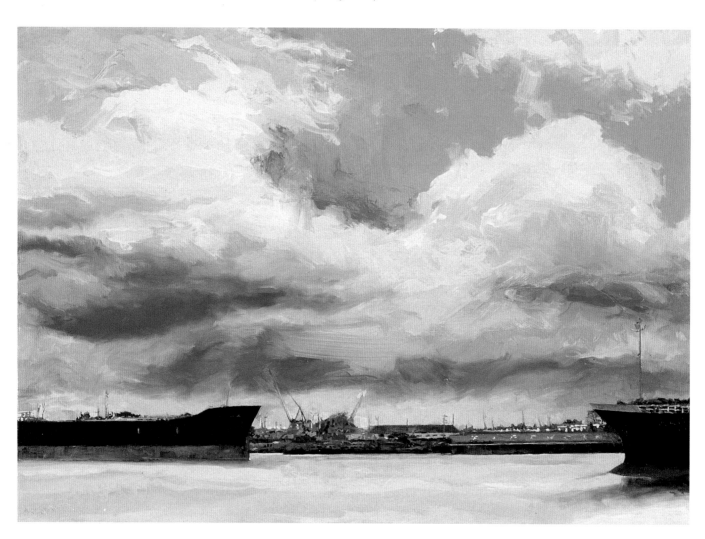

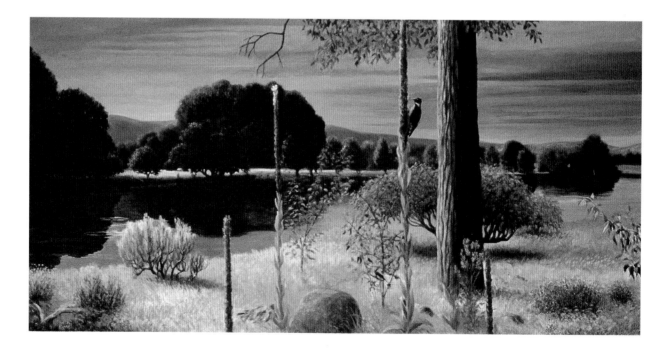

ABOVE:

JAMES LAVADOUR
Bloodline | *1998*
oil on board, 36 × 72"
Courtesy of PDX Contemporary Art Gallery, Portland

UPPER LEFT:

ROGER JONES
Kittitas Canyon | *1997*
acrylic on canvas, 24 × 48"
Courtesy of the artist and Linda Hodges Gallery, Seattle

LOWER LEFT:

ROGER JONES
Ellensburg Sunrise | *1997*
acrylic on canvas, 18 × 36"
Private collection. Courtesy of Linda Hodges Gallery, Seattle

FAR LEFT:

PAT SERVICE
Cranberry Flats | *1997*

acrylic and oil on canvas, 46 × 66"
Private collection. Courtesy of the artist and Buschlen Mowatt Galleries,
Vancouver, B.C.

LEFT:

CORI CREED
Arbutus Tree | *2000*

oil on canvas, 48 × 52"
Collection of Thoma Cressey Equity Partners. Courtesy of Buschlen Mowatt
Galleries, Vancouver, B.C.

BELOW:

LINDA BROCK
Craddock Beach | *2000*

acrylic on canvas, 16 × 20"
Collection of the artist

RIGHT:

HENK PANDER
Burning the New Carissa | *1999*
oil on linen, 63 × 81"
Courtesy of Davidson Galleries, Seattle

BELOW:

JULIA RICKETTS
Encircled | *1998*
acrylic on canvas, 30 × 40"
Collection of Microsoft Corporation, Redmond, Washington
Photo: Richard Nicol

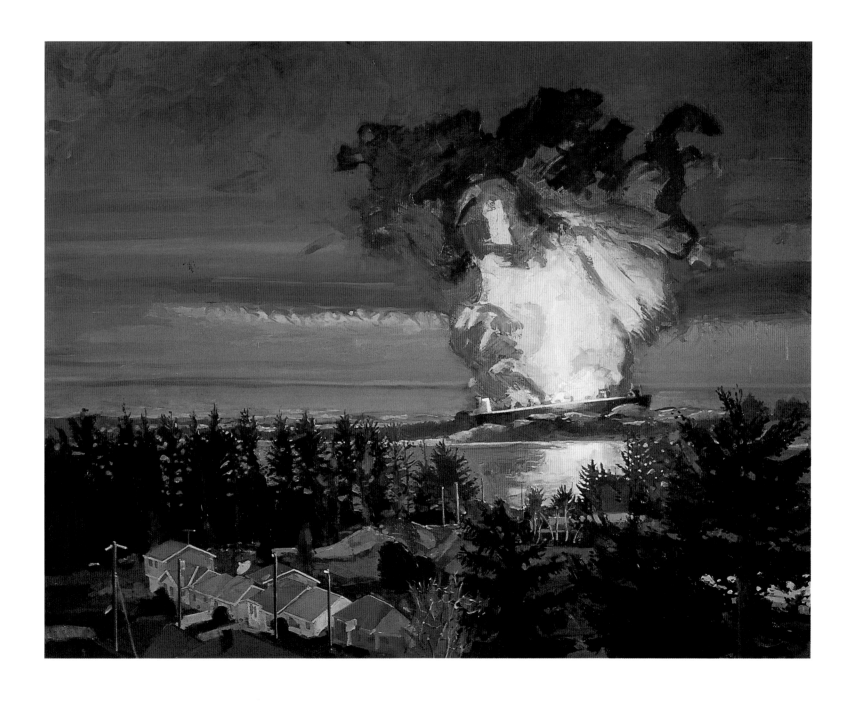

LEFT:

EDMOND JAMES FITZGERALD
Zieg Sketching at Index | 1940
oil on canvas board, 9 × 12"
Collection of Jo and Len Braarud. Courtesy of Braarud Fine Art,
La Conner, Washington

BELOW:

EUSTACE ZIEGLER
Jim FitzGerald Painting | 1940
oil on canvas board, 10 × 12"
Collection of Jo and Len Braarud. Courtesy of Braarud Fine Art,
La Conner, Washington

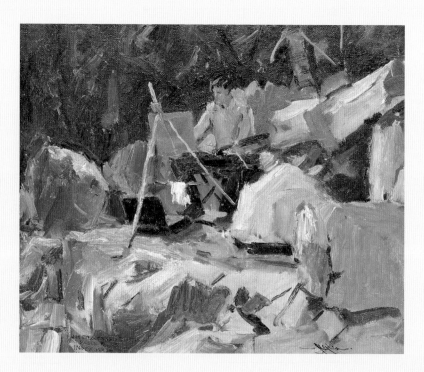

Artist Biographies

Louis B. Akin
p. 46
b. 1868 near Corvallis, OR | d. 1913 Arizona

Louis Akin, grandson of pioneers who arrived via the Oregon Trail in 1852, grew up in the Portland area and studied art in New York. In 1903 he was commissioned by the Santa Fe Railway to paint the Hopi Indians at Oraibi, Arizona, a body of work that was widely reproduced. Akin settled in Flagstaff and from there took a trip to the Fraser River area of British Columbia in 1909; *Osborns Pass, B.C.* is thought to be a painting he made in that area. He died four years later of pneumonia at the age of forty-four.

James Madison Alden
p. 28
b. 1834 Massachusetts | d. 1922 Florida

James Madison Alden, a descendant of the *Mayflower* Pilgrim John Alden, traveled the length and breadth of the Washington Territory for seven years, beginning in 1854 with the U.S. Navy's survey of the Pacific coast and then with the Northwestern Boundary Survey as official artist. In the latter role he explored and documented the territory from Vancouver Island inland to the Continental Divide. Alden produced hundreds of watercolor sketches, over three hundred of which are extant today.

Guy Anderson
p. 104
b. 1906 Edmonds, WA | d. 1998 La Conner, WA

Guy Anderson was a central figure in the Northwest School, a loosely defined modernist movement of painting inspired by nature, executed in a muted palette, and conveying personal, intuitive visions. Anderson was raised in Edmonds and, at the age of twenty, spent a year on Long Island as the recipient of a Tiffany Foundation scholarship, painting landscapes while studying the masters in New York museums. After his return he worked part-time at the Seattle Art Museum, hanging exhibitions and teaching children's art classes, through the 1930s and early 1940s (with two years spent teaching in Spokane for the Works Progress Administration Federal Art Project). He became close friends with Morris Graves and, later, with Mark Tobey, whose interest in Eastern cultures and philosophies influenced Anderson. His abiding interest in the human figure and, since childhood, Asian and Northwest Coast Indian art found full expression in his mature work, produced after he moved to La Conner, in the Skagit Valley of Washington, in the mid-1950s. He painted actively into his nineties.

Jane Baldwin
p. 80
b. 1908 Spokane, WA | d. 1991 Spokane, WA

Painting by the age of six, Jane Baldwin was educated at Washington State College and was a fixture in the lively Spokane art community in the 1930s and 1940s. She was a charter board member of Spokane's WPA Art Center. Baldwin worked extensively in watercolors, and received national exposure for her block print and wood engraving work. She was among the regionalists who excelled in portraying the feel of their homeland, in her case the Palouse of eastern Washington.

Maxwell Bates
p. 103
b. 1906 Alberta | d. 1980 Victoria, B.C.

Maxwell Bates described himself as "the product of the period of Art Nouveau, pared down by the prairie wind." Bates began creating expressionist works in his twenties but, after receiving little encouragement, went to London to study architecture; there his paintings met with increasing success until the interruption of World War II. After the war, during which he spent four years in a Nazi concentration camp, Bates returned to Calgary to paint, teach, and work as an architect, until a stroke left him partially paralyzed. In 1962 he moved to Victoria and focused wholly on his art for the rest of his life.

Harriet Foster Beecher
pp. 40, 41
b. 1854 Indiana | d. 1915 Seattle, WA

In 1880, fresh from art school, Harriet Foster moved from San Francisco to Seattle and soon married Herbert Foote Beecher, nephew of *Uncle Tom's Cabin* author Harriet Beecher Stowe. She became a successful portraitist, landscape painter, and art teacher. She founded Seattle's first art school in 1881, operated out of a cottage raised on stilts at the shoreline where Indians often camped. Thirty-six paintings by Beecher and her students were sent from Washington to the World's Columbian Exposition in Chicago in 1893. In 1904 she became a charter member of the Society of Seattle Artists, the predecessor of the Seattle Art Museum.

Susan Bennerstrom
pp. 120, 121
b. 1949 Seattle, WA

After exploring the possibilities of several different media, Susan Bennerstrom discovered that chalk pastel was the best conduit for exploring her primary artistic interest: light. She works in the realist tradition because, she says, "It offers me an odd sort of freedom from the constraints of worrying about what is acceptable in the contemporary art world." On first glance her readily accessible landscapes are straightforward descriptions of place, but compositional control allows Bennerstrom the freedom to layer color and work with contrast to convey the emotional power of light.

George Bickerstaff
p. 43
b. 1893 Arkansas | d. 1954 California

Apart from some time in Texas at the start of his career, self-taught artist George Bickerstaff lived and worked in California throughout his adult life. He was a highly productive painter of nature scenes, mostly views of mountains, the desert, and rolling hills covered with wildflowers. Bickerstaff was successful in selling many of his paintings for display in public buildings such as hotels, hospitals, and nursing homes.

Albert Bierstadt
p. 30
b. 1830 Germany | d. 1902 New York

In 1859 the young Albert Bierstadt made his first trip to the American frontier as part of an exploring expedition, a federal survey of wagon roads. Upon his return to New York, Bierstadt combined his Düsseldorf art training with the aesthetic of the Hudson River School to produce grand visions of the American West that enjoyed almost instant success. Museums and collectors clamored for the giant, operatic landscapes executed with an acute sense of the romantic. Bierstadt accumulated wealth and fame; in 1864 his painting of the Rocky Mountains sold for twenty-five thousand dollars, then the highest price paid to date for any work of art, and he was the focus of New York's first ticker-tape parade. He painted *Puget Sound, on the Pacific Coast*

in 1870, ten years before he set foot in the area (his previous trips took him only as far north as the Columbia), probably based on his reading of books such as *The Heart of the Continent* by his traveling companion Fitz Hugh Ludlow, and *Canoe and Saddle* by Alfred Powers. Bierstadt continued to produce his formulaic visions even as critical and public taste turned to new styles; he declared bankruptcy in 1895 and died in relative obscurity seven years later.

Linda Brock *p. 127*
b. 1952 *Alberta*

Linda Brock grew up in a farming community east of Edmonton, Alberta, where she found nature hard to ignore; her memories are of vast blue skies, evening meteor showers, blizzards, hail, and the aurora borealis. "I grew up," she says, "believing that nature was alive and had a soul." She began painting landscapes after she moved to Pender Island in British Columbia and received a travel easel from the estate of a friend from her past. She used the easel to paint *Craddock Beach,* and took a shard of rock home with her "to convince myself that the rocks there are, indeed, red."

Michael Brophy *pp. 1, 23, 144*
b. 1960 *Portland, OR*

Apart from a year's study in Italy, Brophy has lived in Oregon all his life. His Northwest landscapes convey the tension when nature and human endeavor meet. "I'm not interested in a romanticized or sanitized vision of nature," he says, "but one in which the marks of civilization are given their due." With *Curtain* and *Tree Opera I,* Brophy is playing up the drama of one environment replacing another—reminding us that 150 years ago, the region was mostly a raw forest. In *Swarm* and *People's View,* Brophy shows his ability to deal with serious subjects in a humorous way. "I'm really a city guy in nature," Brophy says. "I like the idea of nature on the edge with people pressing against it."

Grafton Tyler Brown *p. 32*
b. 1841 *Pennsylvania* | d. 1918 *Minnesota*

Grafton Tyler Brown is believed to be the first African American artist in the West. He lived in California, where he had a successful lithography business, and Canada before moving to Portland in 1886. Brown was the first treasurer of the Portland Art Club, the first art association in the Northwest.

The location of *Mt. Hood from John Day's Station* is just west of the point where the John Day River flows into the Columbia.

Louis Bunce *p. 64*
b.1907 *Wyoming* | d. 1983 *Portland, OR*

Louis Bunce was one of Oregon's earliest masters of modernist genres. He studied art in Portland in the early 1920s before achieving his dream of transferring to the Art Students League in New York City. In the 1940s he became friends with a number of young artists—Pollack, de Kooning, Motherwell, Rothko—at the core of the Abstract Expressionist movement. In 1949 he and his wife started the Kharouba Gallery in Portland, the first to show contemporary art there.

Kenneth Callahan *pp. 19, 67*
b. 1906 *Spokane, WA* | d. 1986 *Seattle, WA*

Over the course of his long career, Kenneth Callahan was a major figure in Seattle's art community. He wrote art columns for Seattle newspapers and for national publications such as *ARTnews;* his home was a gathering place for many local artists; he was a curator for the Seattle Art Museum from 1933 to 1953; he was an influential member of Seattle's loose affiliation of artists formed in 1937, the Group of Twelve, and a vocal supporter of innovation and modernism in a conservative art town; he was a visiting art professor around the country; and, not least, he exhibited internationally and had major solo shows in New York, Boston, Washington, D.C., San Francisco, and Seattle. Amazingly, he was for the most part a self-taught artist. Callahan said he strove in his paintings to convey "that eternal truthfulness and permanence that lies below the surfaces of life and objects."

Margaret Gove Camfferman *p. 69*
b. 1881 *Minnesota* | d. 1964 *Everett, WA*

Margaret Camfferman was a student of Robert Henri in New York; a portrait he painted of her is now in the Seattle Art Museum's collection. Camfferman painted *View from Old Homestead Ranch* in the mid-1930s, soon after a period of study in Paris with the modernist artist André Lhote. She was a member of the Group of Twelve along with her husband, Peter Camfferman, with whom she founded the Brackenwood art colony at their property on Whidbey Island, Washington. Camfferman was for years a prominent member of the Women Painters of Washington.

Peter Camfferman *p. 76*
b. 1890 *Holland* | d. 1957 *Langley, WA*

Arriving on Whidbey Island, Washington, in 1915, Peter Camfferman built his home by hand with his wife, the artist Margaret Gove. Camfferman settled in to four decades of painting landscapes of Puget Sound and the surrounding foothills, returning to his native Europe periodically for training in the School of Paris tradition. A member of the Group of Twelve, Camfferman questioned the public's insistence on realism, "as if the photograph of a clock depicted the spirit of time and the electrical apparatus resembled the fluid which moves it. . . . Such a simple object as an apple is no longer an apple when it is painted."

Emily Carr *pp. 3, 58, 59*
b. 1871 *Victoria, B.C.* | d. 1945 *Victoria, B.C.*

In prim and proper Victoria, in the midst of the Victorian age, Emily Carr was the town character. She went to San Francisco, England, and France to study art at a time when most female artists stayed home. She ran a rooming house and raised vegetables and animals to support herself, and kept a menagerie of creatures including sheepdogs, monkeys, tropical birds, and a pet vulture. She smoked and swore in public, remained single all her life, and traveled alone to isolated wilderness areas on the coast of British Columbia. Later in life she lived with her animals in a small covered wagon for months at a time at various painting sites outside Victoria. Carr felt a spiritual connection to her subjects, and her paintings—of abandoned native villages, totem poles, individual trees and rain forest scenes, and gravel pits or beaches under a pulsating sky—are immediately recognizable. In 1944, the year before she died, Carr received $1,260 for forty-six paintings, the first to be sold in a commercial gallery. In contrast, at a recent gallery sale, one of her early paintings fetched more than one million dollars.

George Catlin *p. 11*
b. 1796 *Pennsylvania* | d. 1872 *New Jersey*

At age twenty-seven, George Catlin abandoned his law career in favor of painting. A year later, on encountering a delegation of Plains Indians, Catlin—a self-taught artist—found his subject, and subsequently devoted himself to depicting the cultures of North and South American native tribes in art and in ethnographic texts. His prolific work

is considered an invaluable historical record. Catlin's "Indian Gallery," a show of his work that toured the United States and Europe, inspired artists Paul Kane and John Mix Stanley to document scenes of tribal life.

Ralph Chessé p. 110
b. 1900 Louisiana | d. 1991 Ashland, OR

Although Ralph Chessé often painted African American figures, it still came as a surprise when his son discovered, upon Chessé's death, that his birth certificate listed him as "colored." Subsequent research revealed that Chessé's great grandmother was a slave. Ironically, Chessé's obscurity as an artist—not commensurate with his talent and output—may have been due in part to people's inability to embrace a (perceived) white artist who painted black subjects. He was known for his work with marionettes, which included producing a popular national children's television series featuring a bee named Brother Buzz. After spending over fifty years in the Bay Area, Chessé moved to Ashland, Oregon, at the age of eighty-four. For the first time, Chessé painted with his left hand (as a "lefty," he had been retrained as a boy to use his right hand)—and, also for the first time, he painted landscapes.

Fay Chong p. 108
b. 1912 China | d. 1973 Seattle, WA

Fay Chong came to Seattle in 1920. After studying art at Broadway High School (along with George Tsutakawa), he made a living as an engineering draftsman and as an art teacher. In 1968 and 1971 Chong completed his bachelor's and master's degrees in art education at the University of Washington. He studied art and calligraphy during trips to China and, in his work, rendered contemporary Northwest landscapes in watercolor combined with traditional Asian media—Chinese brushes and ink stick on mulberry paper, with an accompanying description in Chinese calligraphy.

Sally Cleveland p. 122
b. 1952 Portland, OR

"My work is neither environmental nor political," Sally Cleveland says. "It is a combination of personal history and the exploration of a dark, beautiful, and awkward region." The Arco Juneau, the Tidewater, and the Agility on the Willamette River is from Cleveland's series 100 Views of Sauvie Island, 1999. In the 1920s, Cleveland's grandfather owned several acres on Sauvie Island, which is located twelve miles northwest of downtown Portland at the confluence of the Columbia and Willamette Rivers. Cleveland imagines that the island has not changed much since then—except, perhaps, for the views of freighters across the water.

John Cole p. 119
b. 1936 England

John Cole moved to the Pacific Northwest in 1968 and later settled in Bellingham, Washington. He travels often to various parts of Washington, Oregon, and British Columbia to paint. "The Northwest landscape certainly stands alone in its power over me," he says. "There is a mystical essence about the rivers and mountains that draws me to confront the subject directly." The location of Sherars Falls is the outlet for the Deschutes River in Oregon, located about fifty miles south of the Columbia River, where native fishermen have traditionally netted salmon.

Cori Creed p. 127
b. 1973 Vancouver, B.C.

Cori Creed has spent most of her life on Vancouver's North Shore. As a child she took nature walks with her parents and her brother, occupying herself for hours turning over rocks or inspecting the crevices of tree bark. "The intense color in Canadian landscape is not always obvious," she says. "A forest floor that initially seems drab, on closer inspection lights up with orange-red needles and vivid yellow-green moss." It is the color combinations of the natural world that impel Creed to paint.

Emily Inez Denny p. 16
b. 1853 Seattle, WA | d. 1918 Seattle, WA

Emily Inez Denny was the first child born to white settlers in Seattle, two years after her pioneer parents arrived at Alki Point. Denny showed an early interest in art and, encouraged by her mother, taught herself to sketch and studied drawing and painting briefly with several artists, including Harriet Foster Beecher. Despite ongoing health problems, Denny worked at her painting throughout her life, depicting early Seattle scenes and events and picturesque landscapes. Her stated artistic goals were "Fidelity to nature" and "Nothing if not indigenous." Denny was also the author of two books, Blazing the Way (1909) and Reminiscences (1915).

The untitled painting of Smith's Cove depicts the home of Dr. Henry Smith, a settler who came west by wagon in 1851, the same year that Denny's parents arrived at Alki Point.

William Elston p. 115
b. 1949 Idaho

William Elston grew up in Spokane, Washington, and lived there, in California, and in the Northeast before moving to Seattle in 1985. He resides and works in Pioneer Square and often paints scenes from his neighborhood. In painting Kingdome Elston recalls being attracted to "the sense of light and airiness, the sense of scale, and an echo of those old paintings that depict the ruins of the Roman Coliseum seen through the streets of a more modern Rome."

Robert O. Engard p. 5
b. 1915 Pennsylvania

Robert Engard studied fine art at Washington State University and then became involved in the WPA Federal Art Project in Spokane, Washington, where he studied watercolor painting with Vanessa Helder and taught lithographic drawing and printing. With Helder he painted the Grand Coulee Dam during its construction. Engard was an instructor at the College of Visual Arts in Spokane, Burnley School of Professional Art in Seattle, and Spokane Falls Community College.

John Fery p. 40
b. 1859 Austria | d. 1934 Everett, WA

John Fery combined a European classical art education (in Vienna, Düsseldorf, and Munich) with a love for travel and adventure to create panoramic visions of the American West. In 1910 Fery became the first artist hired to paint landscapes for a railroad, as part of the "See America First" campaign of the Great Northern Railway. In twenty years Fery created 362 paintings of the West for railway stations, hotels and lodges, and businesses around the country. He spent the warmer months outdoors and the cold months turning sketches into paintings in his studio, first in St. Paul, then in Milwaukee, and finally on Orcas Island, Washington. A fire there when he was seventy destroyed all of his sketches from forty years of travel, but he continued painting.

Edmond James FitzGerald pp. 65, 130
b. 1912 Seattle, WA | d. 1989 Ohio

Edmond James FitzGerald, called Jim by his artist friends, is best known for his watercolors of marine scenes. After graduating from art school in San Francisco, FitzGerald studied in Seattle with Mark Tobey and Eustace Paul Ziegler, and later kept a studio down the hall from Ziegler's on the waterfront at Pier 9 (now 61). He and Ziegler were great friends and in the 1930s went on frequent painting trips together into the Cascades and to Alaska; their paintings of each other were done near artist Erik Johansen's cabin at Index, Washington. FitzGerald later joined the faculty of the National Academy of Design in New York City.

Edgar Forkner p. 62
b. 1867 Indiana | d. 1945 Seattle, WA

Edgar Forkner studied at the Art Students League in New York and taught in Chicago before coming to Seattle in 1914. As a midwestern artist he was drawn by the scenic possibilities of the Northwest, and specialized in floral and marine subjects. His paintings were shown in the first exhibition of the Seattle Fine Arts Society in 1914, and won prizes at later exhibits of the society; he also exhibited at the Seattle Art Museum annually from 1935 to 1940.

Martina Gangle p. 81
b. 1906 Woodland, WA | d. 1994 Portland, OR

As a child, Martina Gangle had to work to help support her six siblings. Perhaps this early experience gave her empathy for working people, the subject she favored in her work as a painter and accomplished printmaker. An activist for the unemployed, Gangle was arrested numerous times at protests. She and her husband ran a Communist bookstore and distributed a leftist newspaper, and because of her Socialist leanings she found her work with the WPA Federal Art Project in Portland to be deeply meaningful. In her works she variously painted herself as a welder (from her wartime work in the shipyards) and as a field worker; in the untitled painting included here, a WPA-era mural study, she is the woman carrying a flat of strawberries.

Théodore Gégoux p. 56
b. 1850 Montreal | d. 1931 California

A French Canadian with academic European art training, Théodore Gégoux lived mainly in Oregon from 1909 to 1924. For a time he lived at Champoeg Park near Aurora, Oregon, working as a caretaker in exchange for free lodging. He painted small still lifes to sell there, and portraits of area farmers. Gégoux devoted years to an enormous painting called *The Inception of the Birth of Oregon* (1923), now considered his masterpiece—but when he was unsuccessful in selling it, he left the state for good, settling in California, where he died penniless. (The state of Oregon acquired the painting in 1979.)

Sanford Robinson Gifford p. 25
b. 1823 New York | d. 1880 New York

Sanford Gifford was one of the country's leading luminists, suffusing his paintings with light to create an atmosphere at once serene and emotionally charged. Gifford maintained that "landscape painting is air painting," with topographical features as backdrop. He traveled widely, and in the summer of 1874 visited the Washington Territory; *Mount Tacoma from Puget Sound* is an oil sketch (with visible pencil marks) produced during this trip as the basis for two larger paintings of Mount Rainier created later in his New York studio.

Richard Gilkey p. 107
b. 1925 Bellingham, WA | d. 1997 Wyoming

Richard Gilkey's great-grandfather, a Skagit Valley pioneer, helped build the levees to protect the farmland that, three generations later, his great-grandson painted. Gilkey lived for years in Seattle but painted continually in the Skagit country, on occasion renting studios in Stanwood, La Conner, and Florence, Washington. He painted outside during the day, even in winter (he cut the fingertips off his gloves and kept his paint tubes inside his jacket). In 1970 he purchased an abandoned church in Stanwood that he used as a studio until 1975, when he finally acquired a home in the area, a rundown farm on Fir Island, where he painted for the rest of his life. Gilkey's distinctive Skagit landscapes were actively exhibited and collected, and in 1990 he won the grand prize at the Osaka Triennial, an international competition with over thirty thousand entries.

William Givler p. 98
b. 1908 Nebraska | d. 2000 Portland, OR

William Givler attended the Cathedral School in Portland, where it is said that the parish house custodian taught him to draw. He attended the Museum Art School for two years and studied for another four at the Art Students League in New York along with fellow painter Louis Bunce. Givler returned to Portland with the intention of teaching for just one year at the Museum Art School, but stayed for forty-two years; he built the curriculum into an accredited degree program and was dean from 1944 until his retirement in 1973. He exhibited landscape paintings and prints in a personal Impressionist style that remained consistent throughout his life.

Robert Alexander Graham p. 62
b. 1873 Iowa | d. 1946 California

After studying at the Art Institute of Chicago and the Art Students League in New York, Robert Graham maintained a studio in New Jersey and then in New York, and made frequent trips west to paint. While based in the East, he was included in sixteen exhibitions at the National Academy of Design. In 1920 Graham moved to Denver, where he was a charter member of the Denver Art Guild and taught at the Denver Academy of Applied Art. *Boats on Lake Union* looks north toward Wallingford from the east side of Seattle's Queen Anne Hill.

Morris Graves p. 66
b. 1910 Fox Valley, OR | d. 2001 California

Over the course of a long, distinguished career Morris Graves melded western and Asian sensibilities in artworks that invite the viewer to share a spiritual experience. Growing up in Seattle, Graves traveled to Asia three times, and as an adult he became fascinated by Zen Buddhist philosophy. In the 1940s he worked at the Seattle Art Museum and studied its Asian art collection. With Tobey, Callahan, and Anderson, Graves was designated a Northwest mystic painter; though the youngest of the group, he was the first to receive recognition in major national exhibitions. "There is but one reason, aside from the personal uplift by expression, that gives me a purpose for painting," Graves said in the 1937 Group of Twelve catalog. "Let it be designated as a spiritual responsibility to share with others my ability to respond to color and form more

directly and more readily than many." Graves traveled widely, lived for some time in the Skagit Valley and Ireland, and, from the early 1960s, resided in California.

Paul Morgan Gustin p. 45
b. 1886 Fort Vancouver, WA | d. 1974 Seattle, WA

"It takes more than artistic cleverness to win the friendship of cloud-haloed summits," wrote one reviewer of Paul Gustin's paintings, applauding his ability to capture in his canvases "the wild soul of the mountain wilderness." His family moved away from the Northwest when Gustin was six, and he returned at age twenty and remained for the rest of his life. One of Seattle's most important early painters and etchers, Gustin was best known for his depictions of Mount Rainier and enjoyed steady sales of his canvases and prints after returning from time spent "on the mountain." He exhibited in prominent museums throughout the country.

Carl Hall p. 85
b. 1921 Washington, D.C. | d. 1996 Salem, OR

Carl Hall came to Oregon during World War II for military training, and settled in Salem after the war. He had already begun to develop a unique Magic Realist painting style in the Midwest; now he transplanted his dreamlike scenes to the Oregon countryside—the Willamette Valley and the coast—in a muted "Northwest" palette of greens and earthy hues, and suffused the atmosphere with mist and shafts of sunlight. He taught in the art department at Willamette University from 1947 until his retirement in 1986, and wrote about art for various popular publications. A 1948 feature on Hall in *Life* magazine brought his work to national attention.

Gaylen Hansen p. 119
b. 1921 Utah

Gaylen Hansen grew up on a farm in northern Utah, where he rode his first saddle pony at the age of six. He has studied or taught art in Salt Lake City, Los Angeles, and Yakima and Pullman, Washington. During sixty years of painting, most of the forms of modern art have influenced his work—but in the mid-1970s, he says, "it became clear that keeping up with all those art movements out of New York was no longer imperative." Out of this realization arose Hansen's singular narrative painting style featuring the adventures of a fictional character, Kernal Bentleg. His nonspecific settings are mythic

and often humorous representations of the high desert country in southeastern Washington where Hansen has lived for the past forty-five years.

B. J. Harnett p. 39

No biographical information available.

Lawren Harris p. 52
b. 1885 Ontario | d. 1970 Vancouver, B.C.

Lawren Harris was a founding member and the acknowledged leader of the Group of Seven, an association of Canadian artists that endeavored to depict their country's landscape in a new, more genuine, and distinctly Canadian way. He wrote the manifesto for the Group's first exhibition in Toronto in 1920. "Art must grow and flower in the land," he stated, "before the country will be a real home for its people." Harris traveled with various members of the Group on sketching expeditions to locations in eastern and western Canada; each summer from 1926 to 1929 he explored the Canadian Rockies. He settled in Vancouver in 1940, by which time he was producing only abstract pieces, works that had a potent effect on artists there.

Lance Wood Hart p. 77
b. 1891 Aberdeen, WA | d. 1941 Eugene, OR

As a teenager and young adult, Lance Wood Hart was recognized for his accomplishments as an actor, stage designer, and artist. After attending the Art Institute of Chicago Hart decided to focus on painting, and returned to his hometown of Aberdeen, Washington, leaving only briefly for duty with the U.S. Army Ambulance Corps in World War I and a period of study at the Royal Academy in Sweden in the 1920s. In this period Hart befriended and offered encouragement to Robert Motherwell, a young artist also from Aberdeen, who went on to become a leading Abstract Expressionist. Hart spent the last ten years of his life in Eugene, teaching painting and drawing at the University of Oregon.

Childe Hassam p. 50
b. 1859 Massachusetts | d. 1935 New York

Childe Hassam is known as one of the foremost American Impressionist painters. After living in Paris from 1886 to 1889, Hassam returned to the East Coast to paint soft, light-filled depictions of his favorite haunts, mostly in New England and New York. In 1908, Hassam visited friend, lawyer, and

amateur painter C. E. S. Wood in Portland and traveled with him on a painting trip to Harney and Malheur Counties in eastern Oregon, which seemed to him "more removed from the railroad and telegraph [than any spot] in the United States."

Paul Havas p. 116
b. 1940 New Jersey

Paul Havas came to the Northwest in the 1960s to earn a master's degree from the University of Washington. He taught there, and then at the University of Idaho and Stanford University, before settling in the Skagit Valley of Washington in the early 1970s. In 1983 Havas moved to Seattle, where he painted cityscapes with complex and innovative perspectives. In the 1990s he also began exploring the mountains, using a realist style to paint nontraditional mountain scenes—as in *Meadow Freshets*, with the view looking down from on high. The painting originated from a 1991 hiking and fishing trip to the Burdeen Lakes in the North Cascades.

Charles Heaney p. 82
b. 1897 Wisconsin | d. 1981 Portland, OR

Charles Heaney moved to Portland in 1913 and worked part-time as a jewelry engraver to support his art career. He explored the vast desert country of eastern Oregon, Utah, and Nevada, absorbing the terrain and studying desert plants, fossils, and the geologic underpinnings of rock formations. Heaney had a prodigious memory for images, and often painted places he had visited years before; he worked on paintings off and on over long periods until he felt he had gotten them right. Like his friend and fellow artist C. S. Price, Heaney was a modest man with a questing spirit, who portrayed in the vastness of his Oregon landscapes a place where one could discover spiritual truths. His planar, almost sculptural style of painting mountains—another of Price's influences—conveys their massiveness and power.

Vanessa Helder p. 92
b. 1904 Lynden, WA | d. 1968 California

Vanessa Helder was a graduate of Seattle's public school system and the University of Washington, where she was a memorable figure with her favorite model, Sniffy the skunk, on a leash at her side. Helder received a scholarship to the Art Students League in New York in the mid-1930s, and regularly exhibited her watercolors in New York even after

returning to Washington for several years to work with the WPA Art Center in Spokane. When the U.S. Bureau of Reclamation commissioned her to document the construction of the Grand Coulee Dam, Helder became the only woman permitted access to the area. Her paintings were shown at major institutions, including the Museum of Modern Art, the Metropolitan Museum of Art, the Whitney Museum, and the Los Angeles County Museum of Art.

Juliana Heyne *p. 121*
b. 1939 Ohio

Equally interested in landscapes and cityscapes, Juliana Heyne aims to create images that convey a strong sense of place. "While I freely manipulate landscape elements to fit my memory of the experience of a site," she says, "I'm also concerned to get at some kind of visual truth that may or may not be 'realistic.'" Heyne currently lives in Seattle.

Abby Williams Hill *p. 44*
b. 1861 Iowa | *d. 1943 Tacoma, WA*

Abby Williams Hill settled with her doctor husband in Tacoma, Washington, in 1889, the first year of Washington's statehood. For the most part Hill eschewed the city's society, using her home as a stopping-off point for extended painting trips in the surrounding mountains, where she camped in the company of her four children. From 1903 to 1906 Hill painted scenes throughout the Northwest and the northern Rockies for the Great Northern and Northern Pacific Railways, which wished to increase the value of their land holdings by promoting settlement there. It was a rarity for such commissions to go to a woman, given the rugged travel required. *Looking Across Lake Chelan,* from the first of her commissions, was exhibited at the 1904 St. Louis World's Fair.

Thomas Hill *p. 35*
b. 1829 England | *d. 1908 California*

Thomas Hill enjoyed great success painting panoramic landscapes of California, particularly of Yosemite, and is purported to have made over five thousand landscapes there. Hill was a founding member of the San Francisco Art Association and a prominent figure, in great demand as an artist until late in his life, when a downturn in the economy and the shift toward modernism coincided with

Hill's suffering a series of debilitating strokes. Beset by depression, the painter who is now considered one of the major figures in American landscape painting died an apparent suicide.

William George Richardson Hind *p. 29*
b. 1833 England | *d. 1889 New Brunswick*

In 1851 W. G. R. Hind traveled from England to join his brother in Canada and took a job as a drawing instructor in Toronto. Ten years later he was the artist on an expedition to Labrador, and the following year he accompanied a group of adventurers to the Cariboo gold fields of British Columbia. *Foot of the Rocky Mountains* shows a Pre-Raphaelite influence, with its focus on foreground details and lack of shadows, in contrast to the style of concurrent painters who drew the viewer's eye up, in awe, to the mountains' peaks.

E. J. (Edward John) Hughes *p. 102*
b. 1913 North Vancouver, B.C.

Although a graduate of the Vancouver School of Art, E. J. Hughes has consciously spurned an expressionist approach to his art in favor of a quasi-primitive style, the better to communicate the awe he feels for the British Columbia landscape. The distinctive character of his work has been called by critics "magically lucid" and "a hallucinatory super-reality of things held long and hard by the unblinking eye." Working from meticulously detailed pencil sketches done on site, he concentrates on marine locations. He has lived for years on the southern coast of Vancouver Island.

Yvonne Twining Humber *p. 88*
b. 1907 New York

Yvonne Humber studied art at the National Academy of Design and the Art Students League in New York and participated in the WPA Federal Art Project in Boston. In 1943 she married and relocated to Seattle, where her husband was a businessman, bringing with her a sophisticated approach to urban regionalism that was a sharp contrast to the dominant Northwest School. She became president of the Women Painters of Washington in 1945 and had a solo show at the Seattle Art Museum in 1946. Characterized as a "hard-edged regionalist," Humber was one of only a handful of Seattle painters in this period to exhibit in major national

shows. But the duties of caring for her aging mother and mother-in-law—and then, after her husband died, his company—left her little time for painting. After selling the company in 1964, she resumed painting and remained active into her nineties.

Walter F. Isaacs *p. 101*
b. 1886 Illinois | *d. 1964 Seattle, WA*

After studying in Chicago, New York, and Paris, Walter Isaacs made a big splash when he arrived in Seattle in 1922—just as his work was included in the Paris Salon—to head the University of Washington's art department. He held this position until his retirement in 1954. "I agree with Cézanne," Isaacs asserted in a 1948 interview, "that nature is the basic source of art, and that the painter must have first-hand contact with nature in order to develop. Painting should be a personal interpretation of nature through skilled technique." Isaacs spent many a summer in the country around Lake Chelan—an area, he maintained, that offers the artist everything he needs.

A. Y. (Alexander Young) Jackson *p. 55*
b. 1882 Quebec | *d. 1974 Ontario*

A. Y. Jackson studied art in Montreal, Chicago, and Paris, and became an official war artist after being wounded in World War I. Jackson helped found the Group of Seven in 1920; the critics' vehement response to the Group's first show was quelled when a painting by Jackson was sold to the Tate Gallery in London, thereby making him the only living Canadian artist with work in the British national collection.

Dorothy Dolph Jensen *p. 73*
b. 1895 Forest Grove, OR | *d. 1977 Seattle, WA*

Painter and printmaker Dorothy Dolph Jensen studied at the Portland Art School, having received prior training in Europe. In 1919 she married Lloyd Jensen, Seattle's most noted framemaker, and remained in Seattle for the rest of her life. Jensen was the only woman in the city during the 1920s and 1930s who did intaglio printmaking with her own press. She was a founder, in 1930, of the Women Painters of Washington and a charter member of the Northwest Watercolor Society. She exhibited in Washington, D.C., Los Angeles, Chicago, and San Francisco.

Frank Tenney Johnson p. 60
b. 1874 Iowa | d. 1939 New York

With Charles M. Russell, Frederic Remington, and W. R. Leigh, Frank Tenney Johnson was among the most famous twentieth-century western genre painters. As a child he watched settlers heading west along the Overland Trail by his family's farm, and began portraying western themes while studying art in Milwaukee under teachers who encouraged his fascination with horses and the frontier. Johnson studied at the Art Students League in New York and worked as an illustrator before heading west at last in 1904, on an assignment for *Field and Stream*. This trip through the Rockies and the Southwest cemented his love of the West, and for the rest of his life he traveled there and made it his subject, with his painting gradually overtaking the success of his illustration work. In 1937 Johnson was elected to the National Academy of Design, the highest honor awarded to American artists.

Pauline Johnson p. 5
b. 1905 Everett, WA | d. 1994 Seattle, WA

Pauline Johnson was a graduate of the University of Washington and received a master's degree from Columbia University. She taught in Ellensburg, Washington, as well as Colorado, San Francisco, New York, and Florida before returning to the University of Washington, where she was a faculty member for over thirty years. Johnson established the art education division there and served as its chairperson. She was instrumental in achieving academic recognition for the university's crafts courses and wrote books on paper and book arts.

Roger Jones p. 124
b. 1941 Ellensburg, WA

Images of the semi-arid country near his childhood home in Kennewick, Washington, and the pastoral landscape of Ellensburg, where he attended college, made a deep impression on Roger Jones. He received a master's degree in fine arts from the University of Washington; Jones credits the program's emphasis on figurative painting and his many years of work at Boeing as a technical illustrator with honing his ability to scrutinize the outside world in an artistically analytical way.

Spencer Percival Judge p. 47
b. 1874 England | d. 1956 Vancouver, B.C.

Spencer Percival Judge came to Vancouver in 1903 and made his living as a freelance artist. In 1917 he joined the Vancouver school system, and retired as its art supervisor in 1941. Judge was a founder of the British Columbia Society of Fine Arts.

Paul Kane pp. 26, 27
b. 1810 Ireland | d. 1871 Ontario

At thirty-three, Paul Kane met George Catlin, whose commitment to documenting Indian ways of life inspired Kane to give up his prior work as a portrait painter. From 1845 to 1848 Kane journeyed by foot, snowshoe, canoe, and horseback along Hudson's Bay Company fur-trading routes from Toronto to the Pacific and back. He traveled throughout the Oregon Territory and applied himself especially to depicting the land and peoples of the Northwest coast and the Columbia plateau before the oncoming invasion of white settlers. Kane returned with five hundred field sketches—of Indians, their customs and possessions, and their surroundings—and from these produced about one hundred oil paintings, which together largely constitute his artistic output. The journals of his travels were published in 1859 as *Wanderings of an Artist among the Indians of North America*.

Clyde Leon Keller p. 63
b. 1872 Salem, OR | d. 1962 Cannon Beach, OR

Clyde Keller enjoyed a long, productive career as one of Oregon's best plein-air Impressionists. After his studio and artwork were destroyed in the great San Francisco fire of 1906, Keller settled in Portland and from 1907 until 1936 ran a gallery/teaching studio/frame shop that was an important gathering place for artists. He was the founder of the Sauvie Island School, a loose association of painters who worked together to develop an identifiable Oregon Impressionist aesthetic in the 1920s. During his ninety-year life, Keller painted over forty-five hundred canvases, including two sold to U.S. presidents, both of which are now in the Smithsonian's collection.

Langdon Kihn p. 54
b. 1898 New York | d. 1957 Connecticut

Langdon Kihn began painting portraits of Indians in 1919, while among the Blackfeet in Montana during a trip west. In 1922 he was commissioned by the Canadian Pacific Railway to paint the Kootenay Indians of British Columbia and the Stoney tribes of Alberta. That same summer, he extended his trip to Vancouver Island, where *Totems* was painted, and returned there in 1924 for another commission. His work was exhibited by the National Museum of Canada in Ottawa and Montreal, and stimulated interest in painting Northwest Coast native subjects among Canadian artists.

Emily O. Kimball p. 36
b. circa 1835 New Hampshire | d. 1902 Massachusetts

Emily Kimball, a teacher, artist, and active member of the women's suffrage movement, traveled throughout the Northwest with her Unitarian minister husband. Kimball painted the view of Olympia twenty years after it became the capital of the Washington Territory. The vantage point from land that appears newly cleared of trees suggests the ongoing, rapid growth of the settlement. The main road, now Capital Way, leads past several recognizable buildings, including the town hall and the home of Captain Nathaniel Crosby, Bing Crosby's pioneer ancestor.

Sydney Laurence p. 87
b. 1865 New York | d. 1940 Alaska

In 1904 Sydney Laurence became the first professionally trained artist to settle in Alaska, and by 1920 he was the territory's most prominent painter. He was lured from a successful painting career—including exhibitions in New York, London, and Paris—and a wife and children by "the same thing that attracted all the other suckers—gold." When Laurence had no luck after several years as a prospector, he turned back to art to make his way, but stayed on in Alaska, leaving his former life behind. In 1923 he opened a studio in Los Angeles, and spent most winters working there or in Seattle, returning to Alaska almost every summer for the rest of his life.

James Lavadour
p. 125

b. 1951 Pendleton, OR

James Lavadour has lived on the Umatilla Reservation in northeastern Oregon, near Pendleton, for most of his life. In creating landscapes, the self-taught artist applies thin layers of mineral-colored paint, dry and wet, to wood panels and then rubs and scrapes to bring forth such images as rock faces engulfed in a rain squall or a sweeping brush fire. "My object has been to display the occurrence of landscape inherent in the act of painting," Lavadour has written. "In paint there is hydrology, erosion, mass gravity, mineral deposits, etc.; in me there is fire, energy, force, movement, dimension, and reflective awareness." Lavadour is the founder of Crow's Shadow Institute, a center for the economic and artistic advancement of tribal artists, on the Umatilla Reservation.

Thayne Logan
p. 69

b. 1900 Missouri | d. 1990 Portland, OR

Thayne Logan pursued painting as a sideline to a successful career as an Oregon architect. One of Clyde Keller's students, he had a style based on Impressionism. In the 1930s Logan worked with the WPA in The Dalles, Oregon. He was four times president of the Oregon Society of Artists and designed the building that houses it, as well as the Shemanski Fountain in Portland. *Sheep's Rock* is set in central Oregon, south of Bend.

Blanche Morgan Losey
p. 84

b. 1912 California | d. 1981 Spain

A graduate of the University of Washington, Blanche Losey created watercolors in the 1930s and 1940s in a crisp, exact style, with the evident influence of Vanessa Helder. In the mid-1940s Losey shifted to Surrealism but continued to depict the natural world. She exhibited regularly in various regional venues, including the Seattle Art Museum and the Henry Art Gallery.

Jock (James W. G.) Macdonald
p. 75

b. 1897 Scotland | d. 1960 Ontario

In 1926 Jock Macdonald left England for Canada to take a teaching position at the Vancouver School of Decorative and Applied Arts. He taught art most of his life—in Vancouver, Banff, Calgary, Toronto, Victoria, and abroad. In Vancouver Macdonald befriended Group of Seven members Fred Varley and Lawren Harris, with whom he

went on wilderness painting trips. "Glory in the beauty of your country," he told his students in Vancouver, "for all the big forces of Nature are around you."

Peter Malarkey
p. 117

b. 1964 Eugene, OR

Peter Malarkey has painted the landscapes of eastern Washington since 1992, in particular the structures created by repeated Ice Age floods. "Painting the relatively new geological strata made me aware of the different ways we have of measuring time, often a combination within one painting—the movement of the sun, the layering of rock, the erosion of earth," he says. Malarkey has lived in Seattle since 1987.

Percy Manser
p. 94

b. 1886 England | d. 1973 Hood River, OR

With his British academic training, Percy Manser painted for some sixty years, almost all of them in Oregon. He avoided the mainstream Portland art scene, preferring to lead the life of a gentleman farmer in Hood River, Oregon, selling paintings out of his barn. He hiked throughout the Columbia Gorge area, creating small field sketches that he sometimes worked into bigger canvases in his studio. He executed many murals for community buildings, exhibited throughout the Northwest, and held solo shows at the Maryhill Museum in Goldendale, Washington.

Alden Mason
Cover image

b. 1919 Everett, WA

Since his childhood on a farm in the Skagit Valley in Washington, Alden Mason has been captivated by the natural world. He studied entomology before finding his life's work as a visual artist, and was an art professor at the University of Washington before becoming nationally recognized as a painter. Mason's *Burpee Garden Series* of the 1970s was part of a 1974 Smithsonian exhibition of Northwest artists' work. Mason's art has developed through many phases, ranging from, for example, the representational landscape included here to the controversial "squeeze bottle" murals at the Washington state capitol building (removed in 1989). It was his early watercolor landscapes, which grew in size until they covered an entire wall—executed with house painters' brushes "so that one brush stroke used up an entire tube of paint," Mason says—that led to the abstracted works for which he is known.

David McCosh
p. 72

b. 1903 Iowa | d. 1981 Eugene, OR

Painter, muralist, and printmaker David McCosh was an influential teacher at the University of Oregon for over thirty-eight years. Previously he taught at the Art Institute of Chicago and with Grant Wood at the Stone City Art Colony in Iowa. McCosh married the respected artist and teacher Anne Kutka, and they came to Oregon in 1934. McCosh developed an individual style derived from Cézanne's angular Impressionism that, in its maturity, explored forests, groves, and thickets and challenged the viewer to *see* the landscape.

Ron McGaughey
Back cover image

b. 1960 Wenatchee, WA

Ron McGaughey's home base is in Manson, Washington, on the north shore of Lake Chelan. Beebe Bridge has been a motif in a number of his paintings over the last fifteen years. About *Beebe Bridge (Entering Chelan County)* he says, "I think the bell-curve shape of Beebe Bridge is particularly striking; it has always held my interest."

Charles C. McKim
p. 50

b. 1862 Maine | d. 1939 Portland, OR

Charles McKim, the most important Impressionist in Oregon, first visited Portland in 1910 and moved there in 1911. McKim quickly became a central figure of the developing art scene; he established a studio, wrote a regular art column, taught painting, and was a founder and the first president of the Society of Oregon Artists. He spent summers in Yachats on the Oregon coast, and winters in Portland, using Sauvie Island as a frequent painting site. While most of his larger paintings are obviously studio works, McKim was essentially a plein-air painter. He is known for his distinctive brushwork and high-keyed palette.

Jack McLarty
p. 91

b. 1919 Seattle, WA

Jack McLarty is a painter and printmaker intrigued by human problems and the life of the city. He recalls being startled when his teacher at Portland's Museum Art School, Clara Jane Stephens, corrected his precise work with her big, thick paintbrushes—but she convinced him to persevere and study art in New York. McLarty attended the American Artists School there, where he was profoundly influenced by Joseph Solman. He decid-

edto settle in Portland, taught for years at the Museum Art School, and in 1961, with his wife, Barbara, opened the Image Gallery, an important exhibition space for local artists that would endure for more than thirty years. The Portland site of *The Gas Station* was Southwest. Fifth Avenue and Madison Street, near the Dentley Hotel, where as a boy McLarty lived with his family.

Neil Meitzler
p. 113
b. 1930 Colorado

Neil Meitzler is mainly a self-taught artist; he considers his only art training a brief time spent with the artist Kenneth Callahan. *Blue Light* represents for him the power and mystery of the Cascades, and the ever-changing moods of our interior landscapes. "While our existence momentarily may appear stable and continuous, we change from day to day," he says. "Finally, only the eroding rock of memory is left." Meitzler currently resides in Walla Walla, Washington.

Richard Morhous
p. 111
b. 1945 South Dakota

Richard Morhous spent most of his childhood in eastern Washington and Montana. After graduating from the University of Washington with a degree in graphic design, he studied printmaking in Melbourne, Australia, the source of his penchant for vibrant tropical colors. Returning to Seattle, Morhous worked as a photographer while exploring various media in his art. Strong allergies to pastels and oils led him to begin painting with acrylics, resulting in the work for which he is best known: expressionist landscapes and city scenes in highly saturated hues.

Kenjiro Nomura
p. 72
b. 1896 Japan | d. 1956 Seattle, WA

Kenjiro Nomura moved from Japan to Tacoma, Washington, at age eleven and began painting at sixteen. He was part of the Group of Twelve, with Kenneth Callahan, Morris Graves, and other notable Northwest artists. His work was often shown at the Seattle Art Museum and, in 1933, was included in a traveling exhibit of the Museum of Modern Art. While interned during World War II at Minidoka, in Idaho, Nomura used paints from sign-painting work to produce a series of depictions of the camp. After his release, his painting style shifted completely to abstraction.

Henk Pander
p. 129
b. 1937 The Netherlands

"My paintings give form to events I have witnessed throughout my life," Henk Pander says, "and are an attempt to make visual sense out of contemporary dilemmas." In researching his series of paintings of the *New Carissa*, a freighter that ran aground near Coos Bay, Oregon, in 1999, Pander followed firsthand the saga of the ship and the numerous attempts to remove it without spilling its oil. He then spent a year and a half in his studio working his drawings into seven giant canvases, including a view from Radar Road of the ship burning. Pender has lived and painted in Oregon since 1965.

William Samuel Parrott
pp. 31, 42
b. 1843 Missouri | d. 1915 Goldendale, WA

As a boy of four William Parrott traveled with his family by "prairie schooner" (a type of covered wagon) to the Oregon Territory, and soon thereafter his artistic talents became evident. It is said that young Parrott crafted his own canvases of cloth, hide, and bark, paints from plants and flower petals, and brushes from his sister's hair. This sounds apocryphal, but Parrott did make his own paints throughout his career—including the intense shade of blue for *Crater Lake,* created by adding ground lapis lazuli to his oil base. In 1867 Parrott opened a studio in Portland for painting and teaching. He exhibited in London and Paris and was the first native of the American West to achieve international success—yet by 1886, at the age of forty-three, he withdrew from public life and became increasingly reclusive. After a period in California, he moved in 1911 to his sister Jane Golden's home in Goldendale, Washington, the town cofounded by the Parrotts. In his lifetime Parrott painted nearly every major natural attraction in Washington and Oregon.

Ambrose Patterson
p. 86
b. 1877 Australia | d. 1966 Seattle, WA

Ambrose Patterson moved to Paris as a young artist and exhibited there and in London and Brussels through the century's first decade. He lived in Australia, Hawaii, and San Francisco before settling in Seattle in 1918. Patterson joined the faculty of the University of Washington, where he established the School of Painting and Design and taught until his retirement in 1947. He was married to the artist and fellow Group of Twelve member Viola

Patterson. In the Group's catalog, he stated, "I have, as most painters, the whole stock in trade—theory, technique, and all the rest. What I would most like to do while painting would be to forget everything of the sort and just go to it with the utmost abandon."

Donald W. Peel
p. 93
b. 1921 Seattle, WA

Donald Peel gained local recognition in the 1950s as a Surrealist whose work combined rock-sharp realism, geometric forms, and color-field abstraction. He had solo shows at the Seattle Art Museum, the Frye Art Museum, and the Henry Art Gallery but in 1958 ceased painting for health reasons and became a sculptor. In the early 1990s he began painting again, using acrylics. His paintings and sculptures are represented in museums and private collections.

Barry Pelzner
p. 123
b. 1946 California

Barry Pelzner's paintings are made on location at sites within a few miles of his home in Portland. Pelzner works with oil crayons, which he considers an oddly uncooperative medium. "The crayons tend to make a crude, grainy mark, and they are only available in a spotty and idiosyncratic palette," he says. "Trying to get them under my control is an ongoing adventure." The work called *1999-12* is from a series entitled *A Diary of the Light.* Each work in this series is based on a narrow palette—in this case, just four colors on a ground of raw umber.

George Douglas Pepper
p. 54
b. 1903 Ontario | d. 1962 Ontario

George Pepper's landscapes are distinguished by a powerful sense of line that plays up the natural rhythm of the land. Pepper's wife, artist Kathleen Frances Daly, was his sketching partner and co-exhibitor throughout their marriage. Together they made sketching trips to remote locations throughout Canada for several months each year, including a 1928 sojourn in British Columbia. In World War II Pepper served as an official Canadian war artist with an infantry division from before its landing in Normandy until after V-E Day. His depictions of battle scenes and portraits of soldiers are considered to be among his finest work.

C. S. (Clayton Sumner) Price *p. 83*
b. 1874 Iowa | *d. 1950 Portland, OR*

C. S. Price worked in Wyoming and Montana as a cowboy and carpenter until the age of thirty-two, before he began his artistic career, starting with illustrations for western stories in magazines such as *Pacific Monthly* (later *Sunset*) and ending with abstractions of the West. Price produced classic illustrations of the Old West until, at the age of forty-one, he became disillusioned with realist art. Though his subject did not change, in his abstract works Price was seeking "the one big thing" that unites us with all creatures and the land. Price lived in Portland from 1929 until his death, leading a modest and somewhat reclusive life even as his work was acquired and exhibited by major museums around the country.

Joe Reno *p. 5*
b. 1943 Seattle, WA

As a young artist Joe Reno worked in the mailroom at the Museum of Modern Art and took night classes at the Art Students League. Aside from this period in New York and military duty in West Germany, both in the 1960s, Reno has been a lifelong resident of Seattle, with a home and studio in the Ballard neighborhood. At the age of six he completed his first mural, in wax crayon, from floor to ceiling on a wall at home. Reno has said that his reason for being is to make art, and he spends nearly all of his time at it, sometimes producing dozens of paintings in a week and other times taking months to finish one. "When you're painting," Reno has said, "it's a state of ecstasy—like peanut butter."

Julia Ricketts *p. 128*
b. 1970 Pennsylvania

Julia Ricketts is a painter and art teacher in Seattle. The rapid collapse and regrowth of her hometown, Pittsburgh, prompted her to explore the growth and evolution of the Northwest's urban landscapes in her art during the 1990s. Ricketts uses maps, architectural plans, and snapshots taken from airplanes, along with observations of her immediate surroundings, to portray a rapidly changing urban environment.

Malcolm Roberts *p. 78*
b. 1913 Seattle, WA | *d. 1990 Seattle, WA*

Malcolm Roberts, Seattle's first surrealist painter, claimed he didn't try to understand his paintings. Roberts attended Broadway High School, along with Morris Graves and George Tsutakawa, and spent a year at the Art Institute of Seattle. He exhibited consistently with the Seattle Fine Arts Society and the Seattle Art Museum through the 1930s, and had a solo show at the museum in 1936. In the 1940s he gave up painting.

Cleveland Rockwell *pp. 33, 34*
b. 1837 Ohio | *d. 1907 Portland, OR*

Trained as an engineer, Cleveland Rockwell worked throughout the eastern states for the U.S. Coast and Geodetic Survey and, during the Civil War, as a topographer for the Union Army. He moved to the West Coast in 1868 as the leader of crews surveying the Oregon and Washington coastlines and the Columbia and Willamette Rivers, ultimately settling in Portland. On retiring in 1892 he devoted his time to making watercolor and oil paintings from his field sketches, most of waterside scenes. Rockwell, like the American luminists, suffused his paintings with a spiritual glow but also much historical detail.

Albert Runquist *p. 71*
b. 1894 Aberdeen, WA | *d. 1971 Portland, OR*

Arthur Runquist *p. 97*
b. 1891 South Bend, WA | *d. 1971 Portland, OR*

The biographies of the Runquist brothers run on parallel tracks. They grew up as farmboys and remained bachelors; both attended the University of Oregon, Portland's Museum Art School, and the Art Students League in New York; they worked on WPA projects in the 1930s and at the Vancouver, Washington, shipyards during World War II; and they shared leftist beliefs. In 1946 they moved to artist Harry Wentz's cottage at Neahkahnie, on the Oregon coast, and lived there for the next eighteen years in relative seclusion, concentrating entirely on their painting. They seemed not to care about money and made do with what was at hand, painting on cardboard, newspaper, and wallpaper. Both brothers painted their

surroundings; Arthur's work included figures and had a stronger sense of line and form, while Albert focused on the landscape and applied a softer, more atmospheric style. They returned to Portland in 1963 and lived there for the rest of their lives.

Lionel Salmon *p. 51*
b. 1885 England | *d. 1945 Tacoma, WA*

Lionel Salmon was educated in London but obtained much of his painting instruction from his artist father. Salmon chose Tacoma, Washington, for his home in 1913 after traveling throughout the northwestern United States and Canada for seven years. He never tired of painting Mount Rainier and estimated he had produced more than two thousand views of the mountain. His base was near the inn at Paradise, where his work was available for sale.

Charles Hepburn Scott *p. 57*
b. 1886 Scotland | *d. 1964 Vancouver, B.C.*

Charles Scott settled in Vancouver in 1912 and was employed as the city school system's art supervisor. In 1925 he became head of the newly opened Vancouver School of Decorative and Applied Arts and brought in Jock Macdonald and Fred H. Varley as faculty members. Occupied with the school's administration for the next twenty-six years, Scott had little spare time for painting, but he shared with his colleagues the desire to find an appropriate idiom for depicting the power of the British Columbia landscape. Scott accompanied Macdonald and Varley on one of their excursions to Garibaldi Park, where he painted *The Black Tusk*.

Pat Service *p. 126*
b. 1941 Port Alberni, B.C.

Pat Service was raised on the west coast of Canada. After graduating from college, she lived in eastern Canada, Scotland, and Venezuela; since 1972 Service has lived in Vancouver and painted fulltime. *Cranberry Flats* has some of the typical elements of her paintings: a big sky, a road wandering off into the distance, and colorful foliage. "Without any specific objects or large structural shapes to attract attention," she says, "I am able to concentrate on color."

Jack Shadbolt *p. 96*
b. 1909 England | d. 1998 Burnaby, B.C.

Jack Shadbolt grew up in Victoria; in his twenties he met Emily Carr, whom he admired greatly. After studying modernist art in New York, London, and Paris, Shadbolt concluded that his greatest source of inspiration would remain the native coastal art he had prized ever since sketching masks at the provincial museum in Victoria as a young man. In 1938 he joined the staff of the Vancouver School of Art, where he would serve as head of painting and drawing from 1945 until 1966. Shadbolt's work has been exhibited by every major art venue in Canada; it ranges in style from powerful social realist works created during World War II to vibrant abstractions.

William Slater *p. 105*
b. 1939 South Carolina

Author Tom Robbins lured William Slater to Washington's Skagit Valley, where Slater has lived for the past thirty years. The two were fellow students at the Richmond Professional Institute in Virginia and became friends when Slater was living in New York. He studied, and then took a teaching position, at Hunter College there, but by 1969 he had tired of the city and remembered Robbins's invitation to visit La Conner. "I liked it," he says, "and I'm still here." Slater's subjects are the natural world and the human figure—"and," he says, "like a good Abstract Expressionist, I like to paint in life scale." Milton Avery has always been his greatest influence.

Gordon Smith *p. 112*
b. 1919 England

Gordon Smith's father was a shopkeeper and amateur watercolorist who encouraged Smith's youthful artistic inclinations. After his parents separated, he emigrated with his mother to Canada in 1933. Smith held his first solo exhibition at the Vancouver Art Gallery after serving in World War II. Since then his artistic work has undergone several shifts, from abstract colorscapes of distant horizons to close-in views of wooded enclaves. "In my painting I try to balance the image with the paint," he says. "I am fascinated with images from the West Coast—but I also want people to see the paint."

John Mix Stanley *p. 14*
b. 1814 New York | d. 1872 Michigan

John Mix Stanley was orphaned at the age of fourteen and painted coaches, houses, and signs before receiving formal training as an artist in Detroit and Philadelphia. Stanley determined to emulate George Catlin in creating a traveling North American Indian gallery. For fifteen years, beginning in 1839, he made extended trips throughout the West, including as draftsman on an 1846 expedition along the Santa Fe trail to California, with Kit Carson as expedition guide. Stanley was the first non-Indian artist in Arizona, and his studio paintings of the Southwest are believed to be the first panoramic western landscapes. He traveled to the Northwest in 1847 and followed the Columbia River inland for a thousand miles. Tragically, three separate fires destroyed most of Stanley's work, including hundreds of field sketches and paintings from travels among forty-three Indian tribes; it is primarily his landscapes that survive today.

Clara Jane Stephens *p. 48*
b. 1877 England | d. 1952 Portland, OR

Clara Jane Stephens was orphaned as a young girl and sent from England to Portland to live with relatives. At eighteen she began supporting herself and her art lessons with work as a stenographer, and traveling to New York for intermittent study at the Art Students League. Stephens participated in summer courses in Venice in 1913 and Carmel, California, in 1914, both led by the prominent American Impressionist and teacher William Merritt Chase. In her paintings Stephens applied her own Impressionist style to plein-air landscapes, urban scenes, and whimsical subjects such as *Ice Cream Parlor*, *Clatsop Beach*, and *Jack-O-Lantern Makers*. Stephens had three solo shows at the Portland Art Museum and exhibited in New York throughout the 1920s and in 1931; she taught at various art schools in Portland, most notably the Museum Art School for twenty-one years.

James Everett Stuart *p. 38*
b. 1852 Maine | d. 1941 California

James Everett Stuart, the grandson of famed portraitist Gilbert Stuart, attended art school in San Francisco and began making trips to the Northwest while in his twenties. In the 1880s he opened studios in Ashland and Portland, Oregon. He traveled and painted throughout the country during his lifetime and produced more than five thousand landscapes, primarily of Oregon, Washington, and California. Stuart's success was not limited by the high prices of his paintings; his work was collected by wealthy clients far and wide, and made him a millionaire. Though his dramatically rendered vistas were typical of landscape paintings in that period, Stuart was an innovator of technique. He developed a process for painting on aluminum that, he claimed (incorrectly), permanently fused the pigments with the metal. One of his aluminum paintings hung for a period in the White House, perhaps keeping company with his grandfather's famous portrait of George Washington.

Fokko Tadama *p. 49*
b. 1871 India | d. 1937 Seattle, WA

Fokko Tadama and his wife, a well-known marine painter, lived at his family estate in Holland and were successful in selling their work in Europe. But tragedy struck when Tadama's wife developed acute psychological problems and was institutionalized. Tadama sought to begin a new life in the United States and came to Seattle around 1910. He held his first solo show there at the Seattle Public Library in 1913. With substantial success in Europe to his credit, Tadama found his work well received, and also ran a successful art school in his name until the Depression, when both his finances and health began to worsen. He then joined the WPA and became an art supervisor in 1937. That year, however, unable to bear his continuing economic straits, poor health, and depression, Tadama committed suicide.

Takao Tanabe *p. 114*
b. 1926 Prince Rupert, B.C.

The son of a commercial fisherman, Takao Tanabe spent his childhood on Vancouver Island and his teens in Vancouver. He was detained in a camp during World War II and attended the Winnipeg School of Art thereafter. Following years of study and travel in New York, Europe, and Japan, Tanabe returned to Vancouver in the 1960s and produced abstract landscapes; in the 1970s he began painting the Canadian prairies in a more representational style. In the 1980s and 1990s Tanabe created highly realistic and atmospheric seascapes using acrylic paints thinned down to a consistency close to water, almost

like tints. Tanabe has received numerous distinctions for his contributions to Canadian culture, including the Order of British Columbia and the Order of Canada.

Jefferson Tester — p. 95
b.1900 Tennessee | d. 1972 Portland, OR

Jefferson Tester was raised in Roseburg, Oregon, with his sister, Amanda Snyder, also an artist. After working in the art department of the Portland *Oregonian* for a time in the 1920s, Tester spent most of his adult life elsewhere—at the Art Institute of Chicago, in New York, where he was a successful commercial artist, and in Mexico, the West Indies, and Europe. He began focusing solely on his painting in the 1940s, developing an Impressionist style. He returned to Oregon in 1963 to marry his childhood sweetheart and stayed for the remainder of his life.

Mark Tobey — p. 20
b.1890 Wisconsin | d. 1976 Switzerland

Mark Tobey, perhaps the most internationally famous artist to emerge from the Northwest art scene, began his artistic career as a commercial artist. He moved to Seattle in 1923 to teach at the Cornish School (now Cornish College of the Arts) and stayed until 1960. Tobey was a staunch supporter of the Pike Place Market, which he painted in the 1940s. He traveled frequently and in 1934 went to Japan for a month to meditate and study brushwork in a Zen monastery; soon thereafter he began developing his signature "white writing," fine white brush strokes densely compressed onto a contrasting field. In 1958 Tobey won first prize for painting at the Venice Biennale, launching a stream of shows in major museums and galleries in the United States and Europe.

Kamekichi Tokita — p. 70
b.1897 Japan | d. 1948 Seattle, WA

Kamekichi Tokita grew up and was educated in Japan; he moved to Seattle in 1919 at the age of twenty-two to work as a tea salesman and subsequently taught himself to paint. With fellow artist Kenjiro Nomura he operated a sign-painting business before World War II, specializing in office-door gilt lettering. Tokita's oil paintings are typically street scenes with signs and billboards as part of his graphic style. Despite two solo exhibitions at the Seattle Art Museum and critical praise,

Tokita never supported himself as an artist—in part, perhaps, because of war-related disruptions to his career. Both Tokita and Nomura were interned at the Minidoka camp near Hunt, Idaho, and painted signs there for the camp administrators. After the war, Tokita continued making signs in Seattle and then, with his family, ran a hotel.

George Tsutakawa — p. 109
b. 1910 Seattle, WA | d. 1997 Seattle, WA

From the ages of seven to seventeen, George Tsutakawa lived with relatives in Japan. In 1927 he returned to Seattle and studied art at Broadway High School and the University of Washington while managing a produce stand. Tsutakawa served with the U.S. Army during World War II—yet, while on leave, he visited his relatives (and met his future wife) in a government internment camp in Tule Lake, California. He earned a master's degree in art at the University of Washington and taught there from 1947 to 1976. Though best known for his fountain sculptures, which he began creating in 1960, Tsutakawa painted throughout his career and explored many styles and media. In the 1970s, with prodding from Mark Tobey and Paul Horiuchi, he began painting with sumi, always from life. Tsutakawa combined his enthusiasm for sumi painting with his love of Washington's natural places—the coast, islands, Cascades, and Olympics—on excursions with his family; his daughter remembers well the artist's regular refrain: "Stop the car!"

Fred H. Varley — pp. 2, 79
b. 1881 England | d. 1969 Ontario

Fred Varley came to Canada in 1912 and moved to Vancouver in 1926. He stayed for a decade, during which the Group of Seven cofounder was inspired to paint landscapes as never before. "British Columbia is heaven," he said. ". . . I often feel that only the Chinese of the 11th and 12th centur[ies] ever interpreted the spirit of such a country. We have not yet awakened to its nature." During this period Varley was head of drawing and painting at the Vancouver School of Decorative and Applied Arts, and cofounder with Jock Macdonald of the short-lived British Columbia College of Arts. He painted *Night Ferry, Vancouver* from memory after his return to eastern Canada. The solitary figure looking out over the stern as the boat pulls away from the city is Varley.

Andrew Vincent — p. 100
b. 1898 Kansas | d. 1993 Brookings, OR

Andrew Vincent had an impact on a host of painters and art educators over the course of close to forty years of teaching at the University of Oregon. He came to Oregon with his family as a boy and, apart from time serving in France during World War I and studies at the Art Institute of Chicago, he lived there his entire life. In Chicago he became friends with artists David McCosh and Lance Wood Hart, and drew them to Oregon. He often vacationed at Cove Palisades near Bend, Oregon, and at the coast, where he produced work for exhibitions throughout his career. A major mural painted by Vincent in 1942 hangs in the state capitol building.

Charles Voorhies — p. 99
b. 1901 Portland, OR | d. 1970 Portland, OR

In his paintings Charles Voorhies drew upon two great traditions, ancient Chinese watercolors and Cézanne's angular Impressionism. Like Charles Heaney and C. S. Price, Voorhies had a poetic vision of the landscape. He developed his own highly personal and characteristic line to show the bony structure of the landscape—perhaps influenced by the architectural training he received as a student at the University of California—and employed a distinctive shade of blue-green as his color signature. Voorhies taught for eighteen years at the Museum Art School in Portland, and made extended painting trips to Spain and Mexico. *Grizzly Mountain* is set in the Siskiyou Mountains near Ashland, Oregon.

Elizabeth Warhanik — p. 61
b. 1880 Pennsylvania | d. 1968 Seattle, WA

Elizabeth Warhanik studied art at Wellesley College and, in Seattle, with Paul Gustin, Edgar Forkner, Fred Varley, and Eustace Ziegler. She came to the Northwest in 1910 after teaching for five years at a mission in Japan. Warhanik was a founder and the first president of Women Painters of Washington. She had two solo shows at the Seattle Art Museum, in 1930 and 1938. "I like to paint when I feel like it," Warhanik said in a 1941 interview, "and this works out all right in my case, as I feel like it real often."

John Webber
pp. 6, 7

b. 1751 England | d. 1793 England

John Webber, the son of a Swiss sculptor and an Englishwoman, received art training as a teenager in Switzerland and Paris. At the age of twenty-four, on the strength of three paintings in a London exhibition, Webber was recruited to be a draftsman on the third of Captain James Cook's great voyages of exploration. The British Admiralty charged Webber with making "Drawings and Paintings of such places in the Countries you may touch at in the course of the said Voyage as may be proper to give a more perfect Idea thereof than can be formed by written descriptions only. . . ." In the course of the four year expedition in search of a Northwest Passage between the Atlantic and Pacific Oceans, Webber turned out some two hundred drawings and paintings on which his reputation as an artist was secured. The sketches included here were made on the west coast of Vancouver Island at Nootka, where Cook stationed the party during April 1778 for repairs to the ships and local exploration.

Wesley Wehr
p. 106

b. 1929 Everett, WA

Wesley Wehr earned a master's degree in musical composition from the University of Washington in 1953. There he became friendly with, and taught music to, Mark Tobey, who in turn introduced Wehr to his artistic circle. Tobey offered encouragement when Wehr began sketching, and in the 1960s Wehr began painting his signature landscapes-in-miniature, no bigger than the palm of your hand. He paints in between pursuing other passions; he writes poetry and holds a research curatorship in paleontology at the University of Washington's Burke Museum. He is the author of a recent collection of essays, *The Eighth Lively Art: Conversations with Painters, Poets, Musicians, and the Wicked Witch of the West.*

W. P. (William Percival) Weston
pp. 53, 74

b. 1879 England | d. 1967 New Westminster, B.C.

In 1909 W. P. Weston came to Canada from London, and over the next twenty years, while working as a high school art teacher, he sought to adapt his painting to the landscape of British Columbia. By the late 1920s he had developed a muscular painting style that suited the raw, untrampled landscapes of the Northwest, quite different from the "civilized" scenes he had learned to paint in England. Weston repeatedly painted lone trees on promontories; in a 1962 interview he explained that he was drawn to "trees that have had a struggle . . . the trees along the shore or up on the mountains. They're like people who have had to fight to live; they've developed character."

Melville T. Wire
p. 68

b. 1877 Illinois | d. 1966 Salem, OR

Melville Wire worked for sixty-one years as a pastor of the Methodist Church of Oregon, a position that necessitated moving from community to community—mostly in southern and eastern Oregon, and along the coast—throughout his career. In that time Wire, a plein-air Impressionist, painted virtually every kind of landscape Oregon had to offer. He studied art at Willamette University, where his passion for painting developed from the age of seven to sixteen. He painted in oils and watercolors and, later, studied engraving at the University of Oregon. Wire was commissioned by the Associated American Artists to do several original engravings for subscribers around the country, an honor unique to him among Oregon artists.

Thomas Wood
p. 118

b. 1951 Richland, WA

Thomas Wood has resided in Bellingham, Washington, since 1973. He credits working sojourns in Europe, the Queen Charlotte Islands, and the Netherlands with contributions to his stylistic evolution. In 1980 he served as apprentice to a master printmaker at the Accademia delle Belle Arti in Florence, and he enjoys alternating between printmaking and painting. Wood has camped and boated in eastern Washington throughout his life, and painted *Near Soap Lake* during a trip with fellow artist Joseph Goldberg.

Rudolph Zallinger
p. 90

b. 1919 Siberia | d. 1995 Connecticut

Rudolph Zallinger was the son of Polish-Austrian refugees who came to Seattle in 1924. His father was an artist, and Zallinger sold his first painting, for five dollars, at about age ten. He played classical piano and, when he won a scholarship to Yale University, had to choose between music and art; painting won out because he thought he could make a better living at it. Zallinger is best known for his celebrated 110-foot mural of dinosaurs at Yale's Peabody Museum of Natural History, for which he won the Pulitzer Prize—and, in the Northwest, for the mural of the 1889 Seattle fire at the Museum of History and Industry. He and his wife, also an artist, lived in Seattle in the early 1950s, but they returned to the East when Zallinger was hired to illustrate a series of scientific books for *Life* magazine.

Eustace Paul Ziegler
pp. 89, 130

b. 1881 Michigan | d. 1969 Seattle, WA

Eustace Ziegler settled in Seattle in 1924 and became, by the 1940s, one of the only artists in the city to support himself wholly from his painting. He was prolific, producing an estimated fifty to one hundred paintings each year throughout his career. He had worked as a minister in Alaska until moving to Seattle, and returned to the Alaskan back country for four months each summer for many years. He then painted from his sketches in the winter months. With Sydney Laurence, he is considered the foremost painter of early twentieth-century Alaska. Unlike Laurence, Ziegler rarely painted a landscape without people in it; he remained fascinated by human interaction with the wilderness areas of the Northwest coast and interior.

Bibliography

[Editor's note: This is not a complete bibliography, but a list of sources used in compiling the artist biographies immediately preceding. Lack of space necessitates limiting this list to books, though my main source in writing the artists' capsule biographies were the clippings files at the Seattle Art Museum and the Vancouver Art Gallery. Finally, David Martin, Michael Parsons, Robert Lundberg, and Len Braarud each supplied information, reviewed sections of the biographies, and made valuable suggestions.]

Allan, Lois. *Contemporary Art in the Northwest.* Roseville East, New South Wales: Craftsman House, 1995.

Allen, Ginny, and Jody Klevit. *Oregon Painters: The First Hundred Years.* Portland: Oregon Historical Society Press, 1999.

Anderson, Nancy, and Linda Ferber. *Albert Bierstadt: Art & Enterprise.* New York: Hudson Hills Press, 1990.

Appleton, Marion Brymner, editor. *Who's Who in Northwest Art.* Seattle: Frank McCaffrey, 1941.

Blodgett, Jean, Megan Bice, David Wistow, and Lee-Ann Martin. *The McMichael Canadian Art Collection (25th Anniversary Edition 1965-1990).* Kleinberg, Ontario: The McMichael Canadian Art Collection, 1989.

Christensen, Lisa. *A Hiker's Guide to Art of the Canadian Rockies.* Calgary: Fifth House Ltd., 1999.

Conkelton, Sheryl. *What It Meant to Be Modern: Seattle Art at Mid-Century.* Seattle: Henry Art Gallery, 2000.

Contemporary Canadian Artists. Toronto: Gale Canada, 1997.

Douglas, Stan, editor. *Vancouver Anthology: The Institutional Politics of Art.* Vancouver: Talonbooks, 1991.

Fields, Ronald. *Abby Williams Hill and the Lure of the West.* Tacoma: Washington State Historical Society, 1989.

Francine Seders Gallery, with an essay by Bruce Guenther. *Guy Anderson.* Seattle: University of Washington Press, 1986.

Goetzmann, William H. *Looking at the Land of Promise: Pioneer Images of the Pacific Northwest.* Pullman: Washington State University Press, 1988.

Harper, J. Russell. *Paul Kane's Frontier.* Austin: Amon Carter Museum/University of Texas Press, 1971.

Henry, John Frazier. *Early Maritime Art of the Pacific Northwest Coast, 1741-1841.* Seattle: University of Washington Press, 1984.

Hill, Charles C. *The Group of Seven: Art for a Nation.* Ottawa: National Gallery of Canada/McClelland & Stewart, 1995.

Kingsburg, Martha. *Art of the Thirties: The Pacific Northwest.* Seattle: Henry Art Gallery/University of Washington Press, 1972.

———. *George Tsutakawa.* Seattle: Bellevue Art Museum and University of Washington Press, 1990.

Le Roy, Bruce. *Early Washington Communities in Art.* (Pacific Northwest Historical Pamphlet no. 4.) Tacoma: Washington State Historical Society, 1965.

Michael, Erika, editor. *The Regional Painters of Puget Sound, 1870-1920: A Half-Century of Fidelity to Nature.* Seattle:

Museum of History and Industry, 1986.

Seattle Art Museum. *Northwest Traditions.* Seattle: Seattle Art Museum, 1978.

Shadbolt, Doris. *The Art of Emily Carr.* Seattle: University of Washington Press, 1979.

Some Work of the Group of Twelve. Seattle: Frank McCaffrey/Dogwood Press, 1937.

Stenzel, Franz. *An Art Perspective of the Historic Pacific Northwest.* Montana Historical Society/Eastern Washington State Historical Society, 1963.

———. *Cleveland Rockwell: Scientist & Artist, 1937-1907.* Portland: Oregon Historical Society, 1972.

Tacoma Art Museum. *One Hundred Years of Washington Art: New Perspectives.* Tacoma: Tacoma Art Museum, 1990.

Thom, Ian. *Art B.C.: Masterworks from British Columbia.* Vancouver: Douglas & McIntyre/Vancouver Art Gallery, 2000.

Tippett, Maria, and Douglas Cole. *From Desolation to Splendour: Changing Perceptions of the British Columbia Landscape.* Toronto/Vancouver: Clarke, Irwin & Company Limited, 1977.

Trenton, Patricia, editor. *Independent Spirits: Women Painters of the American West.* Berkeley: Autry Museum of Western Heritage/University of California Press, 1995.

Tsutakawa, Mayumi, editor. *They Painted from Their Hearts: Pioneer Asian American Artists.* Seattle: Wing Luke Asian Museum/University of Washington Press, 1994.

Tsutakawa, Mayumi, and Alan Chong Lau, editors. *Turning Shadows into Light: Art and Culture of Northwest Early Asian/Pacific Community.* Seattle: Young Pine Press, 1982.

Washington State Historical Society. *Northwest History in Art 1778-1963.* Tacoma: Washington State Historical Society, 1963.

Westbridge, Anthony R., and Diana L. Bodnar, editors. *The Collector's Dictionary of Canadian Artists at Auction, Volumes 1 & 2.* Vancouver: Westbridge Publications Ltd., 1999.